MICHELANGELO

MICHELANGELO

Faces And Anatomy In His Art

Sue Binkley Tatem
Sue Tatem

To order additional copies of this book, contact:
Xlibris Corporation
1-888-795-4274
www.Xlibris.com
Orders@Xlibris.com
87390

TABLE OF CONTENTS

Dedicated to my brainy girls and boys

Shelley who races triathlons
Kyra who can carry three-year-old Charlie up the Cape May Light House
Laurel who sings solos, writes, practices karate, and draws
Connor, the yoga man, who plays the piano and the saxophone
Vickie who wears hair bands and had the first cast
Chloe who shows me how to use my computer and surfs
Maecie who builds sand castles and loves Varmint

This book was typed with a large white purring cat between me and the keyboard. Varmint occasionally made his own entries. Any errors are his.

October 31, 2010

In the room the women come and go
Talking of Michelangelo
 —TS Eliot, Love Song of J. Alfred Prufrock 1914

Defend my dead painting

—Michelangelo

ACKNOWLEDGEMENTS

I thank Raphael Tamargo, M.D., William Wallace, Ph.D. (art historian, University of Washington, St. Louis), John Wesson Ashford M.D. (Stanford), Paul Barolsky, Ph.D. (art historian, University of Virginia), Michael Salcman, M.D., Gilson Barreto, M.D; Marcelo G. de Oliveira, M.D., Helen Palmer, Molly Ireland, Holly Benson, Kathy Chandler, H. Randolph Tatem III M.D., and Sonya Shannon. I also thank the libraries that helped me: Pitkin County Library, library at Fort Carson, and the library at Fort Lewis College in Durango, Leslie J. Savage Library in Gunnison, Old Rock Community Library in Crested Butte, Colorado College library, Colorado State University library, Val A. Browning library Dixie State College Utah, Mesa College library, and the Mesa County Public Library in Grand Junction. I thank Daniel J. Linke, University Archivist of Princeton, for trying to find Simon Abrahams.

Most thanks of all to Ms. Beverly Spicer who kindly did the hard job of editing for me. Beverly is an author, editor, and photojournalist who holds an interdisciplinary master's degree in architecture, neuroscience and Middle Eastern Studies from the University of Texas at Austin. She is a writer and editor for the *Digital Journalist*, online magazine of visual journalism and *The Santiago Times* and blogs for Earthsky Radio, A Clear Voice for Science. She is also an artist and diarist of almost 200 illustrated journals. She's a real Renaissance woman.

CHAPTER ONE

IN THE BEGINNING

INTRODUCTION

Anatomy in Michelangelo's art is a revolution in the way of understanding this Renaissance master. It adds yet another layer of complexity to the genius of his art.

I became interested in the anatomy in Michelangelo's paintings when Dr. Frank Lynn Meshberger published a paper in the *Journal of the American Medical Association* (JAMA) in 1990 showing a brain in a figure of God on the ceiling of the Sistine Chapel. He started a revolution in the way we view the art of Michelangelo.

In his image, I thought Eve's knee was in the position of the pineal gland (Binkley, 1995). Then, I soon noticed that the composition of *The Last Judgment* in the Sistine Chapel is that of an enormous face and published that in my book, *Biological Clocks*, 1997. Both of my observations were in my *Fingertips* poem (Binkley, 1997).

This book is about these and the many other examples where Michelangelo used anatomy, even internal anatomy, in his art.

Judgment is the American spelling; Judgement is the English spelling. But in any case, the painting has an Italian name (discussed below).

In this book I have elaborated on the grand face (Binkley, 1997). I see in *The Last Judgment* and the heart in the *Pietà*. I have described the information about some of the now dozens of anatomical representations discovered by others in Michelangelo's art: brain, kidney, brainstem, lung, male organ in the column, mooning posterior, Jewish influence, Dante's face, and more. I have added my observations about the female reproductive

organs in *The Fall of Man,* teeth, gall bladder, tongue, alimentary canal, and an anatomical interpretation of St. Peter's Basilica.

Anatomical discoveries are listed in chronological order at the end of this book. I have placed a section of images at the end of this book illustrating some of the concepts that I discuss.

After my career in academia as a university biology professor and research scientist, I have been painting and writing for the last 15 years. So where I had a thought relative to the painting process I have stated it.

As I wrote this I have struggled over whether to include some of the more questionable ideas, or too little, so that those ideas are left to die. I invite you to be your own judge and examine Michelangelo's work yourself.

MICHELANGELO IS NOT FOR THE SQUEAMISH

In Michelangelo's work there was a great deal of nudity from the onset of his career. If this bothers you, I squeal, "Don't look!" His early painting, *The Doni Tondi* (1503) of the Holy Family has a row of nudes in the background.

If the external nudity doesn't bother you, perhaps you are upset about the insides or bodily excretions. This book is about the insides in many cases.

Michelangelo spent time dissecting cadavers. Of course what he saw would have turned up in his sculpture and paintings.

If man is created in God's image, then both the outside and the inside are his creations.

If the gospels are inspired by God, then is it not possible that the Renaissance artists were also so inspired?

As I wrote this, new observations popped up every day. One observation let to the next. The more I looked, the more I read, the more I saw.

Michelangelo has painted things some will find crude and it is likely he may have chuckled himself over them. I myself am having trouble finding polite words to describe some of his more ribald renditions.

THE HUMAN FIGURE

Michelangelo's work was all about human figures—figures in sculptures and figures in his paintings. There are supposed to be 391 human figures in *The Last Judgment.*

Not having been to the chapel, I wondered how large the figures might be. I calculated from the size of the painting and estimated that the Jesus

figure was about 7.5 feet high, so the figures appear to be life size or a little larger. When I am painting portraits, I find it easiest to make them life-sized or larger and more difficult to make them smaller. Wallace (2007) points out the combination of large and small figures in Michelangelo's sketches. Large and small figures are also combined in his paintings, especially in the Sistine Ceiling.

Do they all resemble real life people? We know that some of them do and it is my bet that Michelangelo used (and reused) real life people for all the figures. It appears that his habit was to use models, even male models for female figures, throughout his artistic career.

Nickerson (2008) writes of the "*bella figura*," that today's Romans are known for being well dressed. We observed that ourselves on our trip to northern Italy (Modena, Florence, Pisa, Venice). Some of Michelangelo's figures are well dressed, but most are well . . . undressed.

Michelangelo's figures are active. They are muscular. They are interacting, struggling, and often in sensuous way.

CONNECTING THE POUNCES

The book here explores some of the possible "hidden" or "secret" anatomy in Michelangelo's works. To me, it is "hidden" in plain sight.

Scientists and physicians noticed most of these anatomical representations. Probably this is because of our experience with dissections and knowledge of anatomy.

The alternative is that we who see these images are just imagining them.

The large number of possible anatomical representations and the fact that they were discovered and rediscovered by various people at various times supports the notion that the anatomical representations were intended by Michelangelo himself.

For at least some of his paintings, Michelangelo made a preliminary sketch, that is called a "cartoon." This was transferred to the fresco plaster by poking holes along the lines. Then using a bag of powdered charcoal dust, dots were pounded through the holes, so that the sketch was transferred as a series of dots. Sometimes Michelangelo was supposed to have worked by sketching directly on the painting without using a cartoon. Some incised or scraped lines were also used.

The purpose here is not to prove anything to the reader, but rather to lay out the course, a rocky road for me, of the anatomical representations

"hidden" in Michelangelo's work. I hope it begins to make a whole out of the various piecemeal parts that have been discovered.

A friend told me that religious people "don't like" the anatomy represented in Michelangelo's work. It seems to me the faithful would believe that the hand of God guided Michelangelo's brushes and chisels. Michelangelo himself appears to have been deeply religious in a very broad way.

WHERE TO FIND COLOR IMAGES ON THE WEB AND IN BOOKS

I was limited to black and white within the pages of this book. The original paintings were in glorious color.

The easiest place to find color representations of the images in this book is to search for them on the web, either individually, or in groups (e.g. search "*Last Judgment* photos").

They can also be found in books and in *National Geographic* (May 1994). The images in Michelangelo are found in some medical journals. I put the "brain" image from *The Creation of Adam* on the cover of my book, *Endocrinology*. I have listed sources on Michelangelo in the Annotated Bibliography. Illustrations are collected at the end of this book.

There is a splendid virtual tour of the Sistine Chapel online: *www. vatican.va/various/capelle/sistina_ur/index.html*. Or go to gadling.com and click on Sistine Chapel Virtual Tour.

I recommend you glance through the black and white figures at the end of this book right away for a quick overview.

IT'S ITALIAN, *Il Giudizio Universale*

While most of the information that pops up on the web and in the books I have listed are written in English, we should not forget that Michelangelo was probably speaking and thinking in Italian.

The Sistine Chapel is "*Cappella Sistina*" in Italian. Halloween would be "*vigilia d'ognissanti*" meaning "vigil of all saints."

At first I couldn't find the name of the *The Last Judgment* in Italian. I tried to invent a name going from English to Italian. I came up with:

> *Finale Sagezza,* sensible end
> *Finale Verdetto,* end verdict, end deliverance
> *Finale Avvedutezza,* end wisdom
> *Finale Sonsiglio,* end advice

I finally found the name for the painting online. The Italian name for *The Last Judgment* is **Il Giudizio Universale**. "*Giudizio*" means judgment, opinion, wisdom, trial, or sentence. "*Universale*" means universal.

I'm not sure why the translation has not been "The Universal Judgment."

It is also not clear who named *The Last Judgment* (the Pope? Michelangelo?) or the paintings in the Sistine Chapel. We find alternate names for some of them.

DISSECTIONS

Nearly every book about Michelangelo says that he, as did his contemporaries, dissected many dead animals and countless human corpses to study anatomy. He may have participated in public dissections as early as his teen years (Eknoyan, 2000). Eknoyan explains the way permissions were granted for dissections. He writes,: "The church . . . did allow for dissection of the cadavers of condemned criminals . . . Permission to dissect corpses had been granted by Pope Sixtus . . . Michelangelo did most of his dissections at the Monastery of Santo Spirito . . ."

When I trained in biology, dissection of vertebrates and invertebrates was a common learning method. I dissected a frog, turtle, dogfish shark, cat, fetal pig, cow brain, insects, lobsters, clams and more. Most of these were preserved in formaldehyde and had lost their natural colors. I also did some surgery on animals and there the natural colors were present.

Condivi reports that Michelangelo "abandoned the dissection of bodies because the long handling of such corpses had so upset his stomach that he was able neither to eat or drink." (Beck, p.6)

Formaldehyde was discovered in 1859. Prior to that, in the 16th Century Robert Boyle found that spirits of wine could be used as a preservative. Whether this happened in time to preserve cadavers for Michelangelo, I do not know.

The frontispiece of Valsalius' book (*Fabrica*) shows a contemporary dissection that is taking place in the middle of a crowd.

CHAPTER TWO

ANATOMY IN *THE LAST JUDGMENT*

EUREKA! THERE'S A GRAND FACE IN
Il Giudizio Universale

I wrote a description (Binkley, 1997) of the grand face that I believe is the composition for Michelangelo's *The Last Judgment:*

"I noticed that Michelangelo's *The Last Judgment* is composed in the manner of a huge pumpkin face. The vaulting of the chapel shapes the eyes and eyebrows.

The eyes, nose, and mouth regions are lapis lazuli blue, as if one were inside the skull looking out at the blue sky. If one imagines the Sistine Chapel as a sculpture of a skull, and I think that Michelangelo the sculptor did just that, then what he painted is the "pineal gland" view (sometimes called the third eye)—people naked as jaybirds trumpeting in the hole that would be the mouth.

Michelangelo himself dangles like a pip of mucus from the nasal region."

Wallace (2010) called the pigment azurite. The blue pigment was expensive, so I think there is no accident and it was applied exactly where Michelangelo intended to shape the grand face. It also contrasts with the ceiling where there is almost no blue. Perhaps there is even a "crown" in the vaulting of the ceiling above the face.

CORONAL SECTIONS

The "ellipse area of *The Last Judgment* . . . represents a cross-sectional image of the human brain." J. Wesson Ashford (2006) noticed this coronal rendition in the "proper frontal orientation." It is the area containing Jesus and surrounding figures. It contains the "nose" area of the grand face.

Paluzzi (2007) found that the composition of Raphael's *Transfiguration* is a coronal section of the human brain. I was convinced. Gerard David's (1520) *Transfiguration of Christ* also has a coronal brain composition. Paluzzi's work was reviewed by Palmer (2008).

The fact that three artists of the same period attempted similar representations of brain anatomy seems to me to strengthen the argument that Michelangelo fully intended his anatomical representations.

LOCATING THE GRAND FACE

I first found the grand face composition in the 1990s and described it in a poem named *Fingertips* (p. 76) that was published in the *Coyote Bark*, a local poetry magazine.

On September 12, 2010, I found that Simon Abrahams wrote about a similar image in Part 3 of his 2005 online articles "Michelangelo's Art Through Michelangelo's Eyes." Abrahams is an art historian and the articles can be downloaded at *www.artscholar.org*. He does not refer to my book and as of this writing I could not locate him. I think he made an independent observation that was similar to mine.

He did not notice, as I did, that Michelangelo's skin appears to be a drip of nasal mucus from the nose but he did mention the trumpeting figures in the mouth. So also did Gonzales who found the Dante image and thought the trumpets were in the neck (discussed below).

When I tried to publish the notice of the grand face, I encountered critics. One criticism is that it was the tendency to see a face. However, this can't explain the observation of the many other anatomical representations that are not faces.

As an aside, the word "pareidolia," a word worthy of a spelling bee, is a psychological word meaning perceiving a vague or random image as something clear and distinct, like viewing animals in clouds. I point out that here, viewing Michelangelo's art, the artist himself painted the images

with full knowledge of anatomy from dissection. I learned about this word from Jessica Palmer.

EYES AND EYEBROWS ARE FORMED BY ORIGINAL CHAPEL STRUCTURE

I think the "eyes" that were in the chapel structure before painting may be the key to the whole composition of Michelangelo's chapel paintings.

In the painted eyes, in the inside corners where eye sand would form, there are small figures that are hard to see in any reproduction I found.

Anatomically, the bits of pink skin found the inside corners of our eyes are called splica semilunaris and the caruncle. The inner edge of the eyelid is called the medial canthus. People in the right eye are pointing to the area inside the corner of the eye that is occupied by tiny figures.

The action in the "eyes" could be considered as taking place in water, that is, the tears.

The left eye has the pillar structure that will be discussed below. The right eye (a crossed eye?) has a small circle of the crown of thorns (a thorn in the eye?).

The cross and the pillar both point to the *Jonah* figure above them.

The "schlera" of the eyes is blue rather than white, suggesting an interpretion as eyeholes in a mask.

The blue tops of the eyes form the tablets of Moses as explained by Blech and Doliner (2008).

I can see an "ear" shape ending in the curved piece as the "earlobe" held below by Catherine. Other long ears are on several lower figures such as Minos.

WHOSE NOSE IS SHOWN? WHAT IS DRIPPING FROM THE NOSE?

In a frontal interpretation the nose appears to me to be that of Michelangelo. In the profile interpretation of Dante's face below, the nose is seen as a profile.

Saint Bartholomew holds the "flayed skin" of Michelangelo, and that becomes a nasal drip in my frontal interpretation. According to Wallace (2010, p. 186), the skin was first identified as Michelangelo's self-portrait in the 1920s but Wallace did not say by whom.

In the view of the Dante profile, the drooping empty skin might be considered a tear. Most references in my list agree that the skin is that of Michelangelo, as if depleted by the tremendous tasks he accomplished.

Blech and Doliner (2008, p. 264) point out that inserting his own face is Michelangelo's way of signing the painting, as signatures were not permitted.

There are two people sitting on rocks at the bottom of the 'nose.' Avoiding unappealing terms, I will call the rocks "dried nasal mucus."

Torrigiano crushed Michelangelo's nose when they were students in Florence. Michelangelo had made fun of Torrigiano's drawings. The cartilage and bone were damaged. The broken area would be just above the area of the Jesus and Mary figures in *The Last Judgment.*

Michelangelo's visage is supposed to be in a corner fresco in the ceiling where Judith and another lady are carrying his head on a tray (*Judith with the head of Holofernes,* Blech and Doliner, p. 185). The head is probably a profile of Michelangelo. The dent is visible in the profile.

Barolsky (1990) wrote at length about Michelangelo's nose.

JESUS AND MARY IN THE NOSE, BUT WHICH MARY? AND THE TEAR

In the "nose" area, Jesus is portrayed without a beard. I think he looks a bit like the Adam figure of the ceiling, but with longer hair.

Mary (are we sure it is his mother? from what we now question about da Vinci, could she be Mary Magdalene at the time of Christ's rising?) is covered up thoroughly. She is probably the most covered up figure in the whole chapel. She is also visibly pregnant. In fact she's covered up twice.

A bright blue blob covers her lower half. The blue blob serves to make her the center of attention in the entire fresco. It is not shown to be added during the restoration in the figure showing the coverups in Vecchi (p. 241). The Jesus and Mary figures were painted clothed by Michelangelo. The jumbled throng is mostly naked.

If Michelangelo painted the blue blob, it might be a tear dribbling from the eye. The rendition has a "transparent" quality that might have been meant to be a liquid. Artistically, it appears he was trying to attract the eye to that spot.

Michelangelo would have been in his early twenties when da Vinci painted *The Last Supper.* Dan Brown (2003) has championed the idea that the figure next to Jesus is Mary Magdalene. In *The Last Judgment,* the

pregnant Mary figure is cuddled next to the Jesus figure. Jesus appears to be protecting her from an angry mob. She is young, not old. I compared the two faces, the one painted by da Vinci and the one painted by Michelangelo. I would not claim they are identical. But I cannot ignore what is "as plain as the nose on your face."

Where might da Vinci and Michelangelo have gotten the idea of Mary Magdalene as the spouse of Jesus? Apparently this might have come from the Gnostic Gospels (2nd-4th centuries AD).

THE MOUTH—HORNS BLOWING, TEETH, AND SALIVA

I was convinced I was on the right track regarding the grand face composition, when I noticed there were people blowing horns in the mouth area. The horns were apparently noticed as well by Gonzalez when he was discovering the Dante profile.

The same trumpeters I identified in my proposed mouth region for the grand face are close to the throat in the profile Dante image and the horns are mentioned by Abrahams in his presentation of Gonzalez' work (Abrahams, 2005, Part 1, p. 8).

There appear to be teeth in the mouth area but they are not aligned by modern orthodontics. I couldn't find any image of Michelangelo's teeth or even an open mouth to see how they might have been. The mouth area has several people blowing trumpets.

Moreover, in the mouth area, there are water and boats where the saliva would be.

IS THERE A NECK?

It looks to me like there is a sort of "neck," although I am hard pressed to say whether it is fleshed out or just the skeleton of the spine that is represented (there are 31-33 human vertebrae if you're trying to match numbers).

IS THE FACE COVERED BY SKIN? MUSCLES? BONE? OR IS IT A SKULL?

I initially proposed that the face might be the skull viewed from the inside, the pineal gland's view as it were, but there are other ways to interpret the composition.

It could be a mask viewed either outside-in or inside-out.

The naked figures are skin colored, so they could represent the skin as seen from the outside. That would leave the blue to fill the "negative space" as artists call it.

IS DANTE'S FACE, NOT THE SAME AS THE GRAND FACE, ALSO THERE IN PROFILE?

As far as I know, the first notice of a large face in Michelangelo's *The Last Judgment* was by Joaquin Diaz Gonzalez in the 1950s. Gonzalez was a Venezuelan diplomat. He published a pamphlet and some books that I was unable to get.

I located his work reviewed in an online article by an art historian, Simon Abrahams, *Michelangelo's Art Through Michelangelo's Eyes* (2005, Part 1, p.5). The article shows a diagram of *The Last Judgment* with the traced profile side by side with a life-mask of Dante Alighieri.

While I found the full frontal grand face obvious, I found the profile very subtle and I'm very impressed Gonzalez discovered it. Abrahams goes on to explain that Dante was Michelangelo's "great master and muse." Dante's "eye" is just above Michelangelo's flayed skin.

Clever Michelangelo may have placed two images, the frontal grand face and the profile of Dante simultaneously in the same painting, *The Last Judgment*. In a different painting by Michelangelo of an old woman (Hartt, Plate 54) there are two faces. The second face in that painting can be seen by rotating the image 90 degrees.

Barnes (1998) explores the influence of Dante on Michelangelo, particularly that some of the figures (Minos, Charon) correspond to Dante's descriptions.

THE PHALLUS IN THE EYE

Having found woman, it would be sexist not to seek man. There are structures all over that could be interpreted as phallical shapes.

A most convincing one is in the one of the eyes of *The Last Judgment* grand face, a sloping pillar. The other eye contains a cross. The whale by *Jonah* in the ceiling is also suggestive.

I was just thinking about how awkward it was for me to discuss the pillar when I found this passage in the book by Blech and Doliner (2008, p. 270).

" . . . we can see that the artist purposely exaggerated the muscular back of the angel raising the base of the column so that the rounded, divided back looks just like a scrotum, complementing the phallic angle of the column. Viewed as a whole it is very clearly the male symbol of the war god Mars."

In the paragraph prior to this, they find the symbol for the female in the cross that is in the other eye. The male symbol is the circle attached to an arrow; the female symbol is the circle attached to a cross. The phallical pillar points to the crotch of Jonah above.

On p. 300-306 they wonder if the Sistine is "nothing less than a huge self-portrait of Michelangelo." They do not mean the grand face. Rather "The images are meant to reflect his life and beliefs." So it's more of a pictorial autobiography than a self-portrait. They further suggest that the ceiling frescoes need a name and suggest "The Bridge" of the spirit, between the living and the dead, spanning different faiths, cultures, eras, and sexualities.

CHAPTER THREE

ANATOMY IN THE SISTINE CEILING

THERE IS A BRAIN IN THE *CREATION OF ADAM*

Frank Lynn Meshberger published an article in JAMA, the *Journal of the American Medical Association,* 1990. He looked at the image of God and the angels and the cloak that surrounds them. He concluded that "the image has the shape of the brain." I rephrase this to say that Michelangelo composed God and the angels in the shape of a brain. Meshberger goes on to describe the details including the angel's leg is the pituitary gland that is located below the brain.

Meshberger's article inspired me to look for anatomical representations in Michelangelo's work.

As far as I know, Dr.Meshberger is an ob-gyn physician in Indiana who has done some stone carving.

I don't know the hurdles Meshberger leaped to publish his paper, but it provoked a skeptical response like one posted on the web "God is more than a flying brain" by Jessica Palmer (2008).

In a *Digital Journal* article (2008) John Rickman proposes that Eve might have been in God's mind and thus is represented in Meshberger's analysis of the brain.

Michael Salcman (2006) worried that "our visual system [might] fill in details and create meaning where no pattern or meaning may have been intended." But he also noted that the "rills and ridges within the concave folds of the drapery strongly resemble the "greenstick" dissection many of us made as medical students by the expedient of scratching the inner aspect of a hemisphere with a dull wooden probe, thus uncovering horizontal

association fibers or such projection systems as the optic radiation—a technique certainly available to Michelangelo in Renaissance Italy."

Wallace (2007) mentions the Meshberger finding in his lectures, but says that he doubts Michelangelo was performing an anatomy lesson on the Sistine Ceiling. He repeatedly refers to the ceiling design as a "spine."

As an aside remark, in some reproductions of the *Creation of Adam* you can see a gray image over Adam the replicates the profile of God. The gray God appears to be blowing life into Adam. This observation was posted without attribution at *www.creationofadam.com*. I found an image that shows it by searching "Creation of Adam photos."

EVE'S KNEE IS IN THE LOCATION OF THE PINEAL GLAND IN *THE CREATION OF ADAM*

My first reaction to Meshberger's extraordinary observation, was to add that the pineal gland, that I studied for years, was in the position of Eve's knee (Binkley 1995).

I used *The Creation of Adam* on the cover on my *Endocrinology* textbook because it had not only the pineal gland but also the pituitary gland, both of which are discussed in the book.

A BRAINSTEM IN A NECK OF *THE SEPARATION OF LIGHT AND DARKNESS*

I first learned about the brainstem in the neck when it was reported on CNN by neurosurgeon Sanjay Gupta.

I was able to get a copy of the article by Suk and Tamargo (2010) by writing to Tamargo's email address, then downloading the paper online. It has lovely colored artwork.

Suk and Tamargo show that the neck region of the God figure in Michelangelo's *Separation of Light and Darkness* painted on the Sistine Ceiling contains the anatomy of the brainstem, and further that the anatomy of the spinal cord can be see running down the torso. They explain that Michelangelo's knowledge of gross neuroanatomy came from his many dissections.

Others suggested previously that the neck structures were intended to depict a goiter (Bondeson and Bondeson, 2003).

Suk is in the Departments of Neurosurgery and Art as Applied to Medicine. Suk is a medical illustrator. Tamargo is a neurosurgeon. They

are at Johns Hopkins in Baltimore. Suk and Tamargo also provoked Palmer so she wrote in her blog, bioephemera, 2010, "Not again with the sekrit Renaissance brain anatomy!"

LUNG IN *THE CREATION OF EVE*

The lung shape is the purple robe of God bestowing life in *The Creation of Eve* on the Sistine ceiling. The lung was proposed by Barreto and de Oliviera (2007) in their book. The "lung" is a purple color and it is the only large swatch of purple in the 9 central paintings on the ceiling. There is some purple in the surrounding areas as in the clothing of *Joel*. The tree behind Adam may be the bronchial tree.

Wallace (2007) notes that *The Creation of Eve* is the exact center painting of the chapel ceiling. The lung would be appropriate for blowing life into Eve.

GALL BLADDER IN *THE CUMAEAN SIBYL*

Barreto and de Oliviera (2007) thought there was a heart shape in the green bag hanging in the *Cumaean Sibyl*. I think it looks more like the gall bladder. I was probably influenced by the fact that the color of the bag is green making me think of bile.

KIDNEY IN *THE SEPARATION OF THE LAND AND WATER*

Eknoyan (2000) reported the representation of a bisected kidney in the mantle of the Creator in Michelangelo's painting of *The Separation of Land and Water* in the Sistine Ceiling.

BACKSIDE IN *THE CREATION OF THE SUN AND MOON*

I was reading the paper by Suk and Tamargo (2010) when I first noticed the visible *gluteus maximi* in Michelangelo's *Creation of the Sun and Moon* that are also on the Sistine Ceiling. This was in their Figure 1C. They did not identify it as the backside of God. The Sun is there as a yellow and orange orb, and the moon appears to have blown behind the other figure.

My dictionary has this slang definition of the word "moon:" "Slang: to expose one's buttocks to as a prank or gesture of disrespect (bef 900)." The use appears to have been around long enough for Michelangelo to have

known about it and used it in his painting on the Sistine Ceiling. Famous incidents of mooning were in wars: Roman soldiers mooned Jewish pilgrims in the First Roman-Jewish War in 80, the Greeks mooned the Crusaders in the Siege of Constantinople in 1204, and the Norman soldiers mooned the English archers in the Battle of Crecy in 1346.

Someone noticed the backside in *Creation of the Sun and Moon* before I did. In a web article dated February 14, 2002, "The Mystery of Michelangelo's *Creation of Adam*," has a footnote 2 that reads "In another Sistine scene, commonly called fresco four, or the *Creation of the Heavenly Bodies*, the Creator's undraped posterior artistically balances the image of the newly created moon." I don't know to whom to attribute the observation. There are several names applied to the same fresco.

This bit of anatomy is more obvious in color reproductions than in black and white. Italian for moon would be "luna."

I was agonizing over whether I should "sell" this "mooning" notion, when I read p. 196 (Blech and Doliner, 2008): "Michelangelo found a way to insert a cosmic put-down . . . There is no delicate way to describe this . . . It seems as if the Lord is mooning Pope Julius II from his own chapel ceiling, sticking out the divine backside over the papal ceremonial area."

Even William Wallace noticed this posterior. In his book of Michelangelo's complete work (1998, p. 164) he notes " . . . a most unusual glimpse of God's backside, a view of the deity described in the Bible but seen only by Moses on Mount Sinai . . ." Barreto and and de Oliveira (2004) interpret this image as a brain, but viewed from underneath, showing the hypophysis (pituitary gland). Ashford (2006) sees this image as a frog brain.

FEMALE REPRODUCTIVE SYSTEM IN *THE FALL OF MAN*

Searching for female anatomy in 2010, I located a candidate in Michelangelo's *Fall of Man*, also on the chapel ceiling. Copplestone's Plate 59 of this painting is especially nice. Here the internal female structures provide the composition. The tree trunk is the vagina. It is wrapped in a snake-woman handing something to Eve. The constricting snake has to be an indication of the muscular function associated with the vagina.

The head of the snake and a tree limb form the uterus.

The tree branches into the fallopian tubes and leafy foliage may represent the fimbria.

It is noteworthy that the tree has leaves as most of Michelangelo's other tree images, including the one near Eve in the same frame, have their branches lopped off or as in *The Deluge* are leafless.

There is no visible apple or other fruit—and it's supposed to be a fig tree though I'm not sure how that was determined.

A flying figure appears to be herding Adam and Eve away from the tree.

The red "angel" could be an ovary with its tube peeled back.

And if this painting is "woman," is there a little joke in naming the fresco *The Fall of Man?*

IS THE ANATOMY OF THE EYE IN *JONAH?*

Abrahams found the anatomy of the human eye in a drapery behind *Jonah* in the Sistine ceiling (his Part One, p. 12). Barreto and de Oliveira (2004) noticed the cross section of the penis in the snout of the fish.

TONGUE IN *JUDITH AND HOLOFERNES*

The tongue is in the small corner figure (the sleeping soldier) to the left of the women carrying the tray. Is Michelangelo sticking out his tongue at someone?

THE WHITE TEETH ARE THE DANCING PAIRS

I noticed what I called the "dancing pairs." They are pairs of standing figures that are on the columns across the capitals from the *ignudi*. The *ignudi* are single figures at the corner of each painting in the central ceiling. The individuals in these pairs are *putti,* children or toddlers. These pairs are naked and they are all white. Then I realized what they represent. They are the teeth. Their legs are the roots. There are 24 pairs of dancers.

There are 20 baby teeth and 32 adult teeth in the human, but I am not sure Michelangelo felt compelled to make the accurate numbers. I have not been able to match the dancing pairs to the specific teeth. It is the molars that have more than one root.

All the teeth are out of their gums. Who knows what set of teeth Michelangelo might have had to work with. There is a diagram of teeth in Vesalius' work (Saunders and O'Malley, 1950) that probably represents knowledge of the time.

GOD'S RED ROBES, ANATOMY A COMMON RED THREAD?

Some of the anatomies have a common element, that they are visible in the red robes on and around the God figures. Going from *The Fall of Man* toward *The Last Judgment*:

There's the **ovary** in *The Fall of Man* in the red angel.

There's the **bronchi** and the **lung** in *The Creation of Eve*.

The **brain** in *The Creation of Adam* is surrounded by a red robe (the meninges).

The **kidney** is in the next panel, *God Separating the Earth from the Waters*, and its "capsule" is the red robe.

The next painting, The *Creation of the Sun, Moon, and Plants*, has the **backside** of God on a figure with a red robe. There's a flying God figure (wooshing in the "wind" from the backside figure?) that I haven't matched very well to anatomy though the digestive system or the liver would make sense. Maybe there's another brain as suggested by Ashford (2006). The plants also seem a bit out of place, or is there manure in which to grow them?

Next to that panel there is the God figure in red with the **brainstem** in *God Separating Light from Darkness*.

Then, with *Jonah*, right over *The Last Judgment*, there is the **eye** made of a swirl of red drapery.

If man is created in God's image, so also perhaps Michelangelo created God in man's image, including his internal structure. The God figures bisect the robes in some of the images.

EVOLUTION AND COMPARATIVE ANATOMY

J. Wesson Ashford, M.D. (2006) offered an ingenious alternative explanation of some of the God figures in the Sistine Ceiling.

On his web site, he posted a theory where he compared a series of different species brains to figures in the ceiling:

Dogfish brain, first day of creation, *Separation of Light from Darkness*
Frog brain, third day of creation, *Separation of Plants, Sun, and Moon*
Cat brain, fourth day of creation, *Separation of Light and Darkness*

Baboon brain, fifth day of creation, *Separation of Land and Water*
Human brain, sixth day of creation, *Creation of Adam*

Again, I point out, that the relevant anatomies are enclosed by the red robes.

CHAPTER FOUR

DISCUSSION OF *THE LAST JUDGMENT*

PANTIES AND BRITCHES

Cardinal Carafa was so offended by the naked figures bearing genitalia, that he and Monsignor Sernini, the ambassador to Mantua, and Cesena organized a "Fig-Leaf Campaign" to remove *The Last Judgment*.

Michelangelo had his revenge. Cesena's face is supposed to be in the scene as Minos, judge of the underworld (bottom right corner). He is adorned with donkey ears, and his genitalia are devoured by a snake.

The artist Daniele da Volterra (the britches painter, *il braghettone*) later covered the naughty bits on both frontsides and backsides of the figures.

Apparently the panties were removed in the restoration but some of them were repainted (Vecchi, p. 241).

IS IT THE COLOSSUS?

Pope Clement VII proposed a gigantic statue, a "colossus" (Beck, p. 17) to be built on the Via Larga. Its height was to be the same as the crenellations on the Medici Palace. It was supposed to be 25 *braccia* or 14.5 meters or 47 feet. That would be thrice the height of the David and it would have to be built in pieces. The Colussus was never built. Michelangelo in turn wrote in 1525 sarcastically about a 78-foot tall colossus. In pondering the idea he mentioned that there might be bells with the noise of the clanging emanating from the mouth. That reminded me of the trumpets in *The Last Judgment*.

So, here's a thought. The face in *The Last Judgment* is big, but how big? The painting's size is:

1370 x 1200 cm
539.3 x 472 in

That comes out to

44.94 x 39.4 feet.

45 feet high seems very close to the 47 feet for the proposed colossus. Coincidence? Or was the thought of the colossus in the back of Michelangelo's mind causing him to think huge when preparing to paint *The Last Judgment* ten years later in 1535?

IS IT THE TEN COMMANDMENTS?

Blech and Doliner (p. 252) compare the upper shapes (upper edge of what is blue, tops of the eyes) of *The Last Judgment* with the shapes that usually represent the tablets of Moses. Indeed, to me, it seems the tablet shape is there as yet another layer of meaning in the painting.

The theme of their book is showing that in Michelangelo's work, Judaism and Jews and the Old Testament play a big role. There is no New Testament on the ceiling, but there are pagan Sibyls that are just not Biblical.

Kugler (1920) discussed the presence of the Sibyls on the Sistine Ceiling as "living, grand, beautiful, and true." On the ceiling five Sibyls share "throne-like niches" with seven prophets. Sibyls were women of antiquity with powers of prophecy—they were female prophets. The sibyls go back into Italian prehistory and there is even the cave of one at Cumae. Perhaps the choice of Sibyls was Michelangelo's way of balancing all the men with images of powerful women and invoking pagan origins.

CAPELLA SISTINA BEFORE IT WAS PAINTED, LINES, AND VISITING NOW

The chapel was constructed beginning 1477 and it opened in 1483. The original architect was named Baccio Pontelli who used proportions

from the Bible for Jerusalem's Temple of Solomon. The Chapel is 130x43 feet and 65 feet high.

Ross King's book, *Michelangelo and the Pope's Ceiling*, p. 19, shows a reconstruction of the interior of the Sistine Chapel as the original ceiling and area for *The Last Judgment* painting would have looked (sketch at the end of this book).

The underlying soil sank and the chapel was damaged. Michelangelo did not want to fresco the chapel's vault. But in May 1508 Michelangelo accepted money from Pope Julius II and began to work on the ceiling.

Let me comment on the composition of the ceiling, as I have commented elsewhere on the composition of *The Last Judgment*. For the ceiling, Michelangelo divided the work into separate "scenes" using "lines." In *The Last Judgment*, the groups of figures are separated by blue areas of "negative space." I would guess the departure from dividing scenes with lines was deliberate though it could reflect a progression in the painting style.

To make these divisions in the ceiling, Michelangelo went beyond the structures that already held up the chapel. He painted fictive moldings, crossribs, and cornices. To these he added painted decorations such as rams heads, *ignudi, putti*, and medallions. The "lines" look like travertine, marble, and sculpted stone.

The ceiling was unveiled unfinished without some gold and blue lapis lazuli that were supposed to be added. Supposedly this was because it would have required re-erecting the scaffolding, but it is possible that Michelangelo was satisfied with the ceiling and had decided to save the blue if he were to paint the area by the altar. I have wondered if somehow it was his idea to repaint the altar area that resulted in *The Last Judgment*.

Today, according to Blech and Doliner (2008, p. 129), after going through the Vatican museums, you enter through a narrow doorway that is near King Minos in the bottom corner of *The Last Judgment*. Guards herd you off the altar area to the main floor that you share with a crowd of other tourists. The guards shout "Silence! No videos! No photos!" I have not been there myself, though I did see the *David* and the Medici Chapel in Florence. I found several "illegal" videos on the web that were shot in the Chapel with glimpses of the frescoes between the heads of shoulder-to-shoulder crowds. My husband recalls entering the Chapel in 1974 and 1975 from the other end.

ORGANIZATION OF THE SISTINE CHAPEL CEILING

The half moon shapes around the edges are called **lunettes**. The triangular segments of a spherical surface are called **pendentives**, such as at the corners. The spaces between two arches or between an arch and a rectangular enclosure are called **spandrels**.

Nickerson (2008, p. 68) and Wallace (1998, p. 142) diagram the ceiling of the Sistine Chapel. Nickerson color-coded and grouped the areas showing Michelangelo's organization (her names in bold). I added the descriptions below to her categories to describe their geometry and their numbers. To her list I have added the medallions, *ignudi*, *putti*, "double wedges," ram skulls, and "dancing pairs."

Scenes from *Genesis* (light backgrounds, in the middle, Wallace's Old Testament, contains the red cloaked figures and God images). There are 9 of these presented as 4 large rectangles and 5 smaller squares.

Scenes of Victory (dark backgrounds, medallions and corner spandrels or pendentives). The corner spandrels are curved triangles and there are 4 of them.

The medallions (are they shields?) appear to represent things like chariots, battles, horses, popes, clothed figures, etc. and my guess here is that they are historical events. The most medallions are shown in the book by Marian (1964). According to Wikipedia some of the medallions represent: Abraham's sacrifice of Isaac, Baal, Baal worshippers slaughtered, Uriah being beaten to death, condemnation of King David for murder and adultery, Absalom beheaded, Joab murdering Abner, Jorum falling from a chariot, and Elijah rising to heaven. There seems to be a theme here of murder and violence.

The Human Family (dark backgrounds, along the sides in the pendentives). There are 8 curved triangles.

Prophets and Sibyls (light backgrounds, along the two sides and at the ends including Jonah and Zackariah, clothed, with books and scrolls, framed by pillars, all seated, and each is labeled). There are 12 of these enclosed by columns in rectangles decorated with the "dancing pairs."

Barreto and de Oliviera (2004) assigned anatomic structures to each of the prophets and sibyls.

Ancestors of Jesus (dark backgrounds, around the edges in the lunettes). Pendentives are triangular segments of a spherical surface. The lunettes are half-donut shaped. They are labeled with names. 12 lunettes are shown in Goldsheider (1963) in black and white before cleaning. The figures are clothed. There are women and children. Barreto and de Oliviera (2004) also assigned anatomies in these paintings such as a scapula in *Salman, Booz, Obeth.*

Putti are figures painted below the Prophets and Sibyls and in between the lunettes. *Putto* means human baby or toddler, child, usually male, often naked, and sometimes having wings. Michelangelo's are naked or with white veils about them. Some appear a bit feminine. Vecchi shows some examples paired with the Prophets and Sibyls with which they appear.

Ignudi are figures found mostly facing the four corners of the five small squares of the Scenes from *Genesis*, simultaneously marking the four corners of the four larger rectangles of *Genesis* but with their backs to them for the most part. There are 20 *ignudi*. They are all seated in all possible positions and are all singles. They are naked but painted in color.

"Dancing pairs" are on the columns that divide the Prophets and Sibyls. They are all white and naked. There are 24 pairs of them.

"Double wedges (also called bronze nudes, or slaves)" frame the lunettes. There are 12 of these double triangles containing 24 figures. The background of the wedges is dark and made me wonder if the figures might be represented as being inside the digestive tract, that is the intestines and the colon. Barreto and de Oliviera (2004) note that branches crossing these slaves point to locations of nearby anatomies.

Rams' skulls divide the double wedges. The middle of each double wedge is occupied by what appears to be a ram's skull. The best images of the skulls I found in Vecchi p. 228. Rams and goats are symbols of Satan. They could also echo Baphomet, a pagan diety with a ram-like head that appeared in the late 12th century. This might be a way that Michelangelo represented

the ever-lurking presence of the dark side. The overall composition of the ceiling may be arranged as a "spine" with "ribs."

PREPARATION FOR PAINTING *THE LAST JUDGMENT*

Originally Pope Clement wanted Michelangelo to paint the Resurrection to replace the fresco of the *Assumption of the Virgin* by Perugino (Hartt, p. 39).

Goldsheider (p. 19) describes the year-long (1534-1535) preparation of the chapel for *The Last Judgment*. "Three frescoes by Perugino and two lunette paintings by Michelangelo were removed . . . The windows in the altar wall were blocked up with bricks."

An inner wall of dried bricks was erected. The wall was built sloping in a foot to prevent accumulation of dust. Practically, my first thought about this is that the "drips" created while painting would drip away rather than run down the surface.

According to Ramsden (p. xxi, v.2), the brick wall was originally prepared for oil painting and not for fresco by Sebastiano del Piombo.

THE PAINTING PROCESS, SECRECY?

Michelangelo did the work on the painting alone with only one assistant, a color grinder. Whether there were more assistants involved is the matter of some debate. Wallace (2007) says there were 13.

Michelangelo began April 1536 and finished in December 1540. Did he want to keep the work secret or did he just like working alone? It might have been easy to see the overall composition at some unfinished stage of the work. Did he wish to hide the anatomies? Or the grand face composition?

UNVEILING *THE LAST JUDGMENT* ON OCTOBER 31

The scaffolding was not removed until the unveiling on October 31, 1541, exactly 31 years after the unveiling of the ceiling. The ten months between completion and unveiling may argue for the deliberate choice of the unveiling date. I found no information that Michelangelo "tweaked" the painting during those ten months. I would guess he may have done so but problems moving scaffolding might have kept him from doing that.

WHOSE FACE IS THE GRAND FACE?

Is the grand face simply that? A face seen straight on? Just another smiley face? Is it the face of Wilson that Tom Hanks painted on a volley ball? Did I dream it was the face of William Wallace? Is it many things at the same time? A face made out of figures. Created in His image? I think the grand face is deliberately painted to hold many possibilities.

IS IT MICHELANGELO'S SELF-PORTRAIT?

Certainly this would be a way for Michelangelo to have the last laughs, to have a little fun with us all, and to sign his painting. Abrahams (2005, Part 3) makes a case by comparing *The Last Judgment* to Volterra's portrait of Michelangelo. I prefer the self-portrait interpretation.

IS IT THE FACE OF GOD OR JESUS?

Well, that would be appropriate for a chapel. And it would be appropriate for *The Last Judgment*. And it would make sense to make the face of God very large.

IS IT DANTE?

Most of the images I could find of Dante were clean shaven and in profile with an enormous frown.

IS IT A MASK?

Another option to consider is that of a "mask" because the blue suggests looking through holes.

The use of masks in the Venetian annual celebration goes back to 1268. Today they are mostly used in the *Carnevale di Venezia* that begins about two weeks before Ash Wednesday and as early as St. Stephen's Day (Boxing Day, December 26). If the face were a mask in *The Last Judgment*, the blue would be the empty holes. It would not explain the date.

Michelangelo had masks in some of his other work. In *his Medici Chapel* there is a mask near *Night*'s shoulder. In one of his drawings, *The Dream*, there is a box of masks.

IS IT A SKULL?

When I first started writing about the grand face, I interpreted the image as a "skull." In that interpretation, the ceiling would be the top of the skull, and it could be viewed from inside out, or from outside in. I put the viewer inside in the central position of the pineal gland.

IS IT A POPE?

After all it was a Pope that made the commission.

I had pretty much put this low on my list of possibilities, but then I found a couple views of the Sistine Chapel that might be interpreted not only as a face, but a face with a hat. Searching for papal hats, I found them with several shapes, but they were all towering. A towering hat is visible (Wallace p. 79) on the sculpted reclining figure in *The Tomb of Julius II*. Blech and Doliner (2008, p. 279) write that under the papal hat is Michelangelo's self-portrait for the tomb.

If this was Michelangelo's plan, to represent a pope in the grand face, then he must have conceived the plan very early after seeing the Sistine Chapel.

I don't think the face is Mary or another woman, because the lower edge seems a bit whiskery.

Other images of Pope Clement VII show him with a beard, but usually not with a huge hat. Julius II is shown with a beard and with an enormous hat. If I have to pick a Pope, then I think the "face" looks more like Pope Julius because of the straight-line mouth edge in white that could be teeth.

Pope Julius II may also be the "model" for the God figure in the ceiling. He may be the "model" for *Moses* in the Julius II tomb located in Rome. But I also see some resemblance to drawings of da Vinci's face.

I found it confusing to try to keep track of Michelangelo's Popes. No wonder, Wallace (2010, p. 385) lists 13 of them in Michelangelo's lifetime!

CHAPTER FIVE

DISCUSSION OF THE SISTINE CEILING PAINTINGS

MICHELANGELO'S CRITICS

Michelangelo had many critics. Indeed, my Internet search of "Critics of Michelangelo" had 1,080,000 hits. The story of the criticism would take another book, so I'll limit myself to a few examples.

Piero Sodrini said the nose on the *David* was too thick. Michelangelo pretended to correct it. Never mind Piero had walked behind the canvas that Michelangelo had put around the scaffolding (Barolsky, 1990).

Aretino was among the many who found the nude figures in the Sistine chapel offensive. Gilio, Gion Paolo, Lomazzo and others felt the nudity was out of place in a religious painting. It was not clear, too complex, and needed religious experts to interpret it. Reproductions, painted and printed, were apparently available to a wide audience.

Michelangelo got even with his critics. A Vatican official who said *The Last Judgment* was not appropriate for a sacred wall was Biagio da Cesena. Michelangelo painted Biagio as Minos the king of Hell with ears of a donkey and a snake consuming his genitals. Aretino's portrait became St. Bartholomew, holding Michelangelo's drained skin.

After all, it *was* Michelangelo's personal last judgment.

PROOF

Reviews aside, there is no scientific "proof" that any of the anatomical structures in Michelangelo's art are intentional. This whole book is speculation and interpretation.

In my opinion, the nearest to proof is his mention that in creating the *Pietà* he was seeking the heart's image. I do not claim to have proved anything.

I note here as an aside that the *Pietà* and the *David* and *The Creation of Eve* all have "trees" with branching trunks cut off. I thought of the "arterial tree" and the branching bronchi by which air is breathed.

The other compelling "evidence" is the now large number of accumulated observed anatomical representations by a large number of diverse individuals.

Usually in my scientific career I had to prove things that we can't see with our eyes, such as the activity of an enzyme. It took a complex procedure to measure it in the laboratory. Here we are looking at images that anyone who cares to may inspect and interpret.

MICHELANGELO'S *terribilità*

I am happy, even joyous, when I am painting. There is sometimes a struggle, but it is a positive one, a solving of problems, a sense of being in the zone. Other trivialities of living disappear and I become absorbed in the work. I would think other artists would have a similar experience.

Michelangelo's personality is sometimes described in not very flattering terms. Words used (Beck, p. 21; Coughlin p. 41) include: outspokenness, sarcasm, innovative, enthusiastic, jealous, restless, assertive, fierce temper, headstrong, and impatient.

His "smouldering, passionate temperament" has been called his *terribilità* (Copplestone, p. 32). *Terribilità* translates to dreadfulness and awesomeness.

Michelangelo believed in working rapidly and perhaps didn't want people to see how quickly he could produce a masterpiece.

But I found his letters to be businesslike and his poetry to be lyrical.

MICHELANGELO'S LETTERS

Seeking proof, I read Michelangelo's letters.

Michelangelo's many letters are sufficient to fill a paperback volume (Stone 1962) or two hardback volumes (Ramsden 1963). The letters are all very down to earth. The topics are money, marbles, food, cloth, friends who are ill or who had died, and in the last letters, Michelangelo's ailments (kidney stones and problems of urination). There is virtually nothing in the letters that explains any hidden images.

I compared the two versions of the letters and found that the Ramsden translations differ from the Stone translations.

The letters and poems are translations, so of course it is possible that something was lost in translation.

In one letter written during a period where there is a dearth of letters and while he was working on *The Last Judgment*, Michelangelo writes to Pietro Aretino, "I have completed a large section of my fresco . . . I grieved . . . because I cannot put to use your conception . . ." and continues on to discourage Aretino from coming to Rome to see the work. Of course, Michelangelo was being sarcastic. He wanted nothing to do with Aretino. According to Ramsden (p.3 in Vol. 2), Aretino responded to Michelangelo's—I thought gracious—rebuff, by sending him cruel and vindictive letters.

Michelangelo didn't want *The Last Judgment* viewed while it was in progress. Apparently even the *David* was hidden during its sculpting. When someone criticized the nose, Michelangelo said he had fixed it when he had made no changes.

I found nothing in the letters that would hint of hidden anatomical images.

MICHELANGELO'S POEMS

Michelangelo's poems I would describe as "romantic" and "lyrical." Much like the letters, there is nothing explicit that tells about hidden images. There are a few words that could be taken as hints.

One line of a poem (Stone, p. 138) is " . . . When divine Art conceives a form and face . . ." The poem goes on to describe modeling in clay and then in marble.

Nims (1998) considers only one poem (5) to refer to a specific work and that is probably the ceiling. Michelangelo describes his physical problems.

" . . . a goiter I got from this backward craning . . . skull scrapes where a hunchback's hump would be . . . I'm pigeon breasted . . . Face dribbled . . .

my guts and my hambones tangle . . . I can swivel my butt about for ballast . . . feet are out of sight . . . up front my hide's tight elastic; in the rear it's slack and droopy . . . the crimps have callused . . . I'm bent like a bow . . ." (excerpted from Nims, 1998, p. 10)

Poem 241 (Nim, p. 121) does say:

"Through many a year . . . the cunning artist from his thought a living image wrought . . . as death drew near . . . things grand in a new way . . . this face and that . . . with your face in sight: Great nature's doomsday . . ."

WHAT IS THE MEANING OF THE TWO UNVEILING DATES?

The scaffolding was removed and the ceiling was shown on October 31, 1512, the Eve of All Saints (King, p. 295). The pope spent the day entertaining the ambassador of Parma and they celebrated Vespers in the Chapel at sunset. Wallace (2008, 2010) gives Nov. 1, 1512, All Saints Day for the unveiling.

Similarly, *The Last Judgment* was unveiled on October 31 as was the ceiling of the Sistine Chapel.

Who chose the date? Was it just a good date for Papal entertaining?

Is it a coincidence that it was the evening we have called Halloween since the 16th century?

Italian for Halloween is *"la vigilia d'ognissanti"* and that means vigil of all saints. It can also be called "Giorno dei Morti" that means day of the dead. Both of these seem appropriate for the subject of the painting.

November 1 is All Saints Day in the Catholic Church also called the Solemnity of All Saints and All Hallows or Hallomas or the Feast of All Souls Day. In its various forms of celebration the Saints and other dead are remembered. So that seems appropriate.

Samhain was a Celtic holiday in Western and Central Europe in the first millennium BC. Samhain was the Celtic new year. It began on sunset of October 31 and extended through the next day. The spirits of those who died the previous year were roaming the earth. The Celts built bonfires on hilltops and there were human and animal sacrifices to honor druid deities. In the first century AD, the Roman Empire had conquered most Celtic areas. The Romans incorporated, adopted, and

absorbed some of the Celtic traditions. This was an online contribution by Brent Lanford.

Pope Gregory VI replaced Samhain with All Saints Day in 835. The previous Celtic lore became part of the popular imagination during the late Middle Ages and the Renaissance (14th to 17th century). Michelangelo used pagan Sibyls in the ceiling, so he would not have been inhibited about using the Samhain date for the unveiling.

I can't tell you for sure why the unveiling date was chosen.

But to use the same date, or almost the same date, twice, first for the ceiling, then for *The Last Judgment* unveilings, seems to be making a point.

IT LOOKS LIKE A JACK-O'-LANTERN

I can't look at the grinning grand face without thinking of a jack-o'-lantern.

But could Michelangelo have made a connection to it?

It sure seems to be a colossal coincidence.

Various histories of the jack-o'-lantern go back into prehistory well beyond the birth of Michelangelo but they are not in Italy. History equates the jack-o'-lantern with the will-o'-the-wisp, corpse candle, friar's lantern, hinkypunk, wisp, and the flicking of light over peat bogs called *ignus fatuus.*

Several sources attribute it to a myth from Ireland, Scotland, Wales, England, Applalachia, and Newfoundland. Stingy Jack offered to trade his soul to the devil in payment for his bar bill. More variations involving using a cross to trap the Devil in a tree so the drinking could proceed.

Early jack-o'-lanterns were carved from turnips or beets. The use of the pumpkin began in America.

There is even a mention of gourds with death in the Bible. A variety was nicknamed "pot of death," according to the Internet, but I inspected the reference in several translations. II Kings 4 Verses 39-41 discusses "wild gourds" that apparently were shredded into a pot. Then the eaters said there was "death in the pot."

Carving vegetable lanterns does not seem to have been popular in Italy. Gourds were carved in Africa thousands of years ago.

Halloween got its name in 1556. Michelangelo was still alive but the paintings in the Sistine Chapel had long since been unveiled.

It seems possible that Michelangelo would have known about both Celtic Samhain (sunset October 31) and about at least the concept, if not the name, of the jack-o'-lantern. On Samhain the Celts believed that the border between the Otherworld and this world became thinnest so that spirits of the dead could pass back and forth. And certainly All Saints Day would have been appropriate for the unveilings.

SKEPTICS

Not everyone can see the grand face or is willing to admit they can see the grand face and some of those who could see it were still skeptical as to whether it was intentional by Michelangelo.

I found critics. Roger Malina (*Leonardo*) did not "dispute" it but offered "skepticam" [sic]. An anonymous negative reviewer at *Neurosurgery* and managing editor Oyesicu wouldn't say if they could see it (Oyesicu took the yes out of his name). Bernadine Barnes (author of a book about *The Last Judgment*) thought "*The Last Judgment* is complex enough that almost any projection can be imposed."

Michael Salcman (2006) and Jessica Palmer (2008) worried about Meshberger's observation in *The Creation of Adam*. Salcman concluded that " . . . the possibly intentional resemblance of the draperies to the brain is . . . supported by Michelangelo's . . . dissection . . ."

Everyone I was able to show the grand face to in person was able to see it. In contrast to these naysayers, Tamargo wrote me that the "face in *The Last Judgment* is very impressive."

Another skeptic is Cristina Ruiz. She wrote (Sunday Times, 2008) that "the certainty that Michelangelo was working to papal direction, and . . . the ceiling's meaning is driven by Catholic . . . [rules and it] . . . is not a diagram or code." She reviews work by Gilson Barreto and Marcelo de Oliveira (2004) who found organs on 34 panels. In the *Creation of Eve* there's a tree trunk that has the anatomy of a bronchial tube and a lung. In the *Cumaean Sibyl* they found a heart, diaphragm and aorta. I looked at these and thought the green structure looked more like a gall bladder. Barreto and Oliveriera (2004) interpret God's chest and upper arms in *Separation of Light and Darkness* as the hyoid bone. They observed that the *Libyan Sibyl* contains the arm bone, humerus, and shoulder socket in the folds of her draperies.

Of course skeptics should keep in mind that Michelangelo taught us artists what to do and they might some day appear in a painting wearing donkey ears or wrapped in snakes.

CHAPTER SIX

ANATOMY IN THE SCULPTURE
AND ARCHITECTURE

PURSUING THE HEART'S IMAGE IN THE *PIETÀ*

Coughlin (1975, p. 74), on the page facing a beautiful photograph of the *Pietà* writes that Michelangelo said he was "Pursuing what he called 'the heart's image'" and continues on to describe details of the sculpture. So, thinking along the lines provoked by Meshberger, I looked for the anatomy of the heart. There does seem to be a resemblance to a dissected heart in the folds of Mary's skirt.

A similar shape resembling heart anatomy is in the lines drawn by the scroll, arm, and drapery of *The Delphic Sibyl*. The *Sibyl* is one of the paintings in the ceiling.

A difficulty in looking for the heart anatomy is that there are many viewpoints from which the heart could be observed, and while the *Delphic Sibyl* is in two dimensions, the *Pietà* is 3-dimensional so that the "heart" might be more or less obvious depending on the viewpoint.

The "heart" image that might have been available to Michelangelo is that among da Vinci's 500 anatomical drawings published in 1489. The drawing I found is very near to the image of the *Pietà*. But my bet is that Michelangelo would have relied on his first hand information from his own dissection experience. Barreto and de Oliveira (2004) also find a heart image in the skirts of Mary, but it is a different image than I propose.

WHAT ABOUT THE *MOSES* SCULPTURE?

Moses and the tomb of Julius II are a puzzlement.

Moses was described as "horny" (Simon Holloway, galusaustralis. com, 2009). I don't think the horns are an accident of translation as some supposed. And I don't buy the idea they are beams of light.

Nor is *Moses* angry, but to me he looks caught, embarrassed. Has he broken a commandment, perhaps coveting his neighbor's wife?

And look at the hand positions, one in his lap, the other dividing his overly long beard making a space. Ladyparts, I wonder?

Moses' beard flows to his lap, long hair as a woman. Wallace (p.84) notes an "inexplicable excess of drapery . . . over the knees" that might be a skirt or a veil. So Michelangelo might have created an androgynous figure when he sculpted Moses. Between his two hands fingering the beard, some people see Michelangelo's self-portrait.

Moses is flanked by sculptures of two women, Rachel and Leah. Rachel fell in love with Jacob; Jacob was tricked by using a veil into marrying her older sister Leah first. Leah is the mother of the six of the twelve tribes of Israel. Rachel and Leah appear in *Genesis* 29: 23-26. Leah was fertile but Rachel was barren; they were rivals. Rachel in Hebrew means lamb, ewe, one with purity. Leah means weary and she had weak eyes. Perhaps Michelangelo is hinting at some "trick" by his choice of placing these particular women next to *Moses*.

According to Blech and Doliner (p. 274), Michelangelo was required to explain the choice of these *Genesis* matriarchs, but I found the explanation to be misdirection by Michelangelo.

So *Moses* still contains a puzzle, and I think that it involves women and what is shaped by the long beard.

I found particularly charming the reclining figure over *Moses* that is wearing the tall papal hat. This is supposed to be a Michelangelo self-portrait (Blech and Doliner, 2008). His impish pose suggests there is something here that is amusing. Moses was married twice and that might explain the two ladies on either side.

ST. PETER'S BASILICA FROM THE AIR!

The most obvious masculine structure is St. Peter's Basilica, the enormous dome that dominates Rome.

Peter is from the Greek *petra* meaning rock or stone. The dictionary defines "peter" as a noun, slang and vulgar, for penis. Penis in Italian is *pene, or organo sessuale maschile*. However, it's use this way is described as being American and dating from 1902. The Italian version of the word is also Peter.

I was struck by an aerial view of the Basilica. I don't even have to draw a line around this one for you. The design of the Basilica went through stages involving architects other than Michelangelo, so it is not clear how much influence he had on the overall footprint of the building.

Nickerson (2008, p. 125) diagrams the progression of designs for the dome area. Her diagram shows four designs and clearly illustrates that Michelangelo was responsible for the final appearance of the dome.

Michelangelo died before the dome was completed. The inscription in the drum base is MT16:18: "You are the rock and on this rock I will build my Church, to you I will give the keys of the kingdom of heaven."

CHAPTER SEVEN

AN ARTIST'S VIEWPOINT

I ALSO PAINT

I have been painting for fourteen years since I retired. I have done thousands of paintings, mostly *plein air* impressionistic paintings with acrylics. I also paint watercolors when I am shut inside—still lifes of shells and fruits, portraits, and other subjects. I've tried egg tempera. Composition is one of the first steps in making most paintings. I think there is no way the compositions in Michelangelo's art would occur by accident.

When I'm painting, I don't think about spiritual stuff or deep meanings. I think about paint and color and value and composition and texture. I usually just paint what is in front of me, but I have done abstracts—drip paintings in the manner of Pollock, miniature abstracts using paint left on plastic plate palettes (including the plate), and in some classes. In the drip paintings, composition occurs during the painting, and the advance work is mainly choice of paint type and colors.

I did make one painting of still life vegetables that were organized into a face. I called it "Fruit Face." I think seeing all this controversy over hidden images, I will now write on the backs of my paintings if I have hidden an image.

I also write (books, articles, poems, email) and the writing does not have much about my paintings so I would not expect to find writing about the painting details in Michelangelo's poems and letters.

I enjoy working alone without interruptions and find parties very tiring. So I can understand why Michelangelo would choose to work alone.

Also, in his time, working alone would have kept people from ascribing his work to his assistants.

As an artist, I know that the composition of Michelangelo's art was deliberate. His paintings were drawn out in advance as "cartoons." He destroyed most of these. They would have been clues to his intentions. But he probably thought they were just trash. I also throw out my preliminary sketches and thumbnails. Who wants to store them? Still, my guess is that Michelangelo saved time and achieved the fresh motion in his painting by doing a lot of it freehand without cartoons.

Bob Ross gives oil painting lessons on PBS. He completes an 18x24 inch painting of a landscape without interruption in 25 minutes. One of his techniques is to first paint the canvas with a wet layer of "liquid white." He then paints colors into the white so that they are automatically lightened. It seems that painting wet plaster might be similar as the white of the plaster might alter the tint. In an online fresco demonstration they say that Michelangelo added a thin surface layer with extra white lime. Doing this made the paintings bright

I make flesh color with white, yellow, and cadmium red light. It is a light orange. Blue is the color complement of orange. Color theory tells artists that strong compositions use color complements. So *The Last Judgment* might be predominantly blue and light orange to take advantage of this.

The pigments Michelangelo used are described in Vecchi (1992):

> Lime white
> Yellow ochers
> Giallolino yellow, lead oxide and tin oxide
> Umber, brown
> Burnt siena, reddish brown
> Lapis lazuli, blue
> Azurite, blue
> Red ocher
> Red lake
> Terre verte, green
> Malachite, green
> Vine, black (burnt grapevine)

Fresco is plaster painted with watercolor while still wet; secca is plaster that has dried, then is moistened and painted with watercolor.

Vecchi (p. 231) shows the areas of *The Last Judgment* that were painted with "panties" in the November 7, 1984-April 8, 1994 restoration. Dates vary in different sources.

The movie, *The Agony and the Ecstasy*, shows rather large scaffolding made of heavy beams and with stairs. Michelangelo's scaffolding was movable so I would expect something lighter and making use of ladders. The movie shows the artist painting while lying down, but he is supposed to have stood up. Michelangelo's own sketch shows him standing and reaching straight over his head to paint the ceiling. The movie shows buckets of paint atop the scaffolding, but I would have expected him to be able to do the work with a palette and leave the pots of paint on the floor.

Wallace (2007) shows "scaffolding" that was used in the restoration that might have been closer to that used by Michelangelo and supposedly used the same support points. It looks like a "tent" stretched below half of the ceiling just below the ceiling.

Reaching overhead to paint would have been difficult. I myself have gotten a "painter's elbow" from using an easel.

I use a spray bottle of water to keep my paints wet, but I didn't find any description of what or if Michelangelo might have used to keep his paint and plaster moist, so perhaps they were not fast drying. Restorers concluded that Michelangelo only painted *buon fresco* (wet in wet) and did not rework the painting *a secco* by rewetting the plaster. There are advantages to using the fresco. The early wet stage is good for underpainting large areas. The buon fresco would be good for refining the painting. The dry fresco at the end would be best for painting small details.

Oil painting solvents smell and that might also have affected Michelangelo's choice not to use them.

The Last Judgment contains 391 people. Michelangelo had to have a composition to organize such a big crowd. A face full of faces was his choice.

Fresco start up art kits are available online for $200 to $550. I haven't tried it yet.

HOW LONG TO PAINT *THE LAST JUDGMENT*?

How long would it take to paint *The Last Judgment*?

I can paint an 11x14 canvas in one hour. It's 154 square inches. *The Last Judgment* is 539.3x472 square inches, or 254,549.6 square inches.

That would take 1652.9 Sue-hours to paint, or 4.5 years at one hour a day. I have no assistants.

If Michelangelo worked four hours a day, it would take him 413 days. Given that he had a much harder type of painting, plus preparation and touchups and fiddling with the scaffolding, I think it is reasonable that he could have done most of it with only one assistant to prepare the paint. Wallace (2007) says there were 13 assistants.

Conner (2009) says there were 456 *giornata*, that is, areas prepared for painting in one day. So that means some over a thousand days were spent in other tasks.

A BRIEF HISTORY OF HIDDEN IMAGES IN ART

Writers play with double entendres. Artists play with hidden images. I went hunting for hidden images in art using the Internet. Hidden images are common. In 2010 I made a list of some of the artists I found whose art may contain hidden images. I added Monet, Pollock, Georgia O'Keefe, and da Vinci to the list I made from the Internet, in chronological order of when they lived.

There's an article online about the "Amazing Hidden Images Found in Leonarda da Vinci." There are gorillas and snakes in the *Mona Lisa* and a scary masked face in the *Virgin of the Rocks*. That is beyond the claims that Mary Magdalene is shown in *The Last Supper*.

Dante is known to have written unflattering passages about his enemies.

Timeline for artists making hidden images

1452-1519 Leonardo da Vinci
1495-1498, da Vinci paints *The Last Supper*
1475-1564 Michelangelo
1481 Botticelli (lungs in *Primavera*)
1483-1520 Raphael
1508-1512 Michelangelo paints the Sistine ceiling
1514-1564 Vesalius
1516-1520 Raphael *Transfiguration of Jesus*
1520 David *Transfiguration of Christ*
1527-1593 Giuseppe Archimboldus
1533 Hans Holbein
1535-1541 Michelangelo paints *The Last Judgment*

1542 ErHard Schon
1840-1926 Monet
1848-1903 Gauguin
1853-1890 Vincent Van Gogh
1887-1986 Georgia O Keefe
1904-1989 Salvadore Dali
1912-1926 Pollock
Aboriginal dot paintings
Roof art

Leonardo is supposed to have hidden Mary Magdalene in plain sight in the figure next to Jesus in a *Last Supper* painting. There's a gorilla in the *Mona Lisa*. One web site claims da Vinci has hidden images, mostly faces, in every painting. So we have movies and books about the *Da Vinci Code* by Dan Brown (2003). The *Mona Lisa* has hidden images—she's smiling because she is not alone. For the purposes of this book, Leonardo is most important because he precedes and overlaps the lifetime of Michelangelo. Michelangelo could have known about the hidden faces in da Vinci.

Some of the hidden images are not so hidden as in the precise painting by Salvadore Dali. The images claimed in Van Gogh's work (lambs, beasts, dragons, Biblical items, the word Japan, etc.) are crude. I never saw them until I looked at the web site article, "Van Gogh Controversy: Hidden Images in Van Gogh's Art."

Archimboldus painted portraits made out of vegetables, sea creatures, and other items. The items are all very visible.

People see female organs in Georgia O'Keefe's flowers.

Salvadore Dali's "hidden" images are sometimes very obvious: For example, he paints swans mirrored in a pool. The mirror image of each swan is the head of an elephant.

One of Pollock's drip paintings is supposed to contain the letters for "Pollock."

Holbein used "anamorphism." A drawing is distorted so that an image appears in its natural form when viewed from an angle. A skull appears in his work, *The Ambassadors*. Michelangelo used the technique in painting the Pauline Chapel (Wallace, 2007).

I myself visited the Orangerie where there are two oval rooms of Monet's murals of water lilies and water. I saw a fuzzy cat and a fuzzy self-portrait in the blue water of the paintings.

Roof Art is only visible from the air. Here it pertains to the aerial view of St. Peter's.

TIMELINE RELEVANT TO THIS BOOK

865-923 Galen's account of worm-like structure, probably the pineal

1267-1337 Giotto de Bondone, drawing accurately from life

1401-1428 Masaccio, life like figures, linear perspective, more naturalistic

1265-1321 Dante Alighieri

1443-1513, Pope Julius II (his papacy was 1503-1513)

1475 Michelangelo was born

1483-1546 Martin Luther

1489 Da Vinci, 500 anatomical drawings

1490 Anatomy theater opens in Padua

1494 term pinea applied to the worm-like structure by Vincent de Beauvais

1498-1499 Michelangelo carves *Pietà*

1508-1512 Michelangelo paints the Sistine Ceiling

1512, October, Michelangelo writes he finished the ceiling.

1512, October 31 (or Nov. 1), ceiling revealed.

1522-1523 Jacopi Berengio da Carpi, *Anatomiam humani* (Bologna, connections to Medici)

1534, September 25, Pope Clement insists Michelangelo paint *The Last Judgment*

1534, September 27, Pope Clement VII dies

1534-1549 Pope Paul III confirms commission for *The Last Judgment*

1534-1537, no letters by Michelangelo found

1535-1541 Michelangelo paints *The Last Judgment*

1540, December, *The Last Judgment* finished

1541, October 31, *The Last Judgment* revealed

1543 Vesalius, *De Humani Corpora Fabrica*, frontispiece shows dissection

1545 Charles Estienne, *De Dissectione Partium Corporis* (On the Dissection of Parts of the Human Body)

1564, Michelangelo dies, he was 89 years old

1564-1616 William Shakespeare

1567 Realdo Columbo publishes *Trattato delle perfette proporzioni*. He was Michelangelo's doctor.

1637 Descartes (published posthumously) *The Treatise of Man* including considerations of the function of the pineal gland

1951, 1954 Joaquin Diaz Gonzalez describes Dante's profile in *The Last Judgment*

1963 Michelangelo's letters translated into English were published

1980-1994 Restoration of the Sistine Chapel

1990 Meshberger finds brain in *The Creation of Adam*

1995 Binkley [Tatem] suggests pineal may be Eve's knee in *The Creation of Adam*

1997 Binkley [Tatem] describes grand face in *The Last Judgment*

1998 Nims translates Michelangelo's poems into English

2000 Eknoyan describes kidney in *Separation of Land and Water* 2003 Bondeson and Bondeson find goiter in in *Separation of Light from Darkness*

2004 Barreto and de Oliviera describe dozens of anatomies in the Sistine ceiling and other Michelangelo art

2005 Abrahams describes anatomies in Michelangelo's art including the eye in *Jonah*

2006 Washford describes evolution of brains on the ceiling, and coronal section in *The Last Judgment*

2010 Suk and Tamargo describe brainstem in *The Separation of Light from Darkness* (alternate to goiter)

2010 Tatem [Binkley] describes heart, gall bladder, female reproductive organs, tongue, teeth, intestine, male parts, Pope's hat, and Mary Magdalene in this book

CHAPTER EIGHT

SOME LAST THOUGHTS

IN HIS IMAGE

It appears to me that the grand overall theme of the Sistine Chapel paintings by Michelangelo is the human being. If I had to name the chapel art, I would call it "In his Image."

Umanisti (humanism) appears to have been born as 15th Century classical studies of poetry, rhetoric, history, and moral philosophy. The term, humanism, dates from 19th century German philosophers. It's a mode of thought or action in which human interests, values, and dignity predominate. That sure describes the work of Michelangelo.

It appears Michelangelo may have tried to represent all the body, internal and external, as one of his themes in the chapel. The Biblical story and the pagan and Jewish backgrounds would be other themes.

MYSTERY OF THE *IGNUDI*

A definition by Shelley Esaak says *ignudo* is a noun from the Italian adjective *nudo* and that it was the phrase coined by Michelangelo to describe the twenty seated male nudes and that none have anything to do with Biblical stories but are, rather, idealized male human forms. The Italian translation I found for *ignudi* (*ignudo* sing.) was naked, without clothing, exposed, and unprotected.

There are 20 ignudi (one is partially missing from damage) at the corners of the 9 scenes from *Genesis* (Wallace, 1998, pp. 142, 147). The

*ignudi a*re all naked and painted in color and are all seated, but they are squirming like first graders.

What could they be? Hands formed by fingers and thumbs with the torso being the palm? Roman letters spelling out something? Greek letters (there are 24 Greek letters)? Hebrew letters? The Italian alphabet has 21 letters. It is missing LKWXY.

There are twenty fingers and toes. Could the *ignudi* be the digits?

The *ignudi* sit like capitals of the columns that frame the Prophets and Sibyls. Across from each *ignudo* is a pair (I called them "dancing figures") of standing nudes that are not painted in color. These appear to be couples of one male and one female each.

Column capital translates to *colonna capitale*. A woman named Vittoria Colonna (1490-1547) was Michelangelo's dear friend beginning in 1536 well after the *ignudi* were painted. So there does not appear to be a relationship to her name.

I think the *ignudi* look like single hands. I have so far looked in vain for a sign language that matches them. It wasn't until 1620 that Juan Pablo Bonet published his first book for the deaf with hand signs in Madrid. Before that there were some sign languages and fingerspelling going back to 710 AD. There are also remarks that men working in quarries used sign language. I had thought that Michelangelo might have spelled out his name or some other important phrase.

Eric and Intukan Dubay ("Famous Freemasons Exposed: Masonry from the Vatican to Hollywood," www.scribd.com) point out hand signs in Michelangelo's paintings that they think are the Masonic "m" hand sign. They show it in both hands of the *Creation of Adam* (ring and middle finger are pressed together) and in the Jesus figure of *The Last Judgment*. The finger sign is also given by an angel in *Jonah*.

If the *ignudi* are not hand signs, what else might they be? An exercise regimen? An artist's dictionary of seated poses?

If the *ignudi* are "hands," maybe their purpose is just to hold the frames of the central panels.

I looked at the word "ignudi" since it was coined by Michelangelo. Other words with "ign" have to do with fire. *Ignis fatuus* is Latin for friar's lantern. It also means the spontaneous combustion of gas from decomposed organic matter. So I guess I could connect the pounces to hint at the grand face (lantern of Samhain) and the gas resulting from the dissections.

Bruschini (2001, p.111) suggests that they are ". . . the Great Belvedere torso...completed with head, arms, and legs, in twenty different

reproductions." He points out (2004, p. 35) that the "...bust and right leg...form an angle of ninety degrees . . . as in . . . the Belvedere Torso." Michelangelo had refused to complete the statue by adding head, arms, and legs. But he may have done that twenty times on the Sistine Ceiling.

Barreto and de Olivieri (2004) think the positions suggest where the anatomies are located.

BOOKS AND SCROLLS

This is not anatomy, but an aside. I noticed this as well.

Many of the figures on the ceiling, around the perimeter, are clothed and have book or scrolls; counterclockwise between vertical pillars, clothed, for example are the Prophets and Sibyls:

> *Zechariah,* book
> *Joel,* scroll
> Erythraen, scroll
> *Ezekial,* scroll
> *Persica,* scroll
> *Libica,* booklet
> *Daniel,* open book
> *Cumaea,* book
> *Isaiah,* closed book
> *Delphic,* scroll
> *Judith and Holofernes,* paper

Is there anything readable on the books? The *Erythraen Sibyl's* book seems to bear writing. Wallace (2007) identifies the clearly visible "Q" and suggests that it is the beginning of some query word (such as "why"). And there's a book and a sheaf of papers in *The Last Judgment.* They are in the "mouth" area next to the figures with horns, perhaps for reading aloud (Hartt, p. 120).

Next to *Jeremiah* there is a scroll with visible letters that look like ALEFV. Blech and Dolinger (2008, p. 217) analyze this for several pages as to whether Hebrew letters are meant. They find Hebrew letters in the ceiling paintings: he' in the legs of *Jonah,* bet in the hands of *Jonah,* chet in *Judith and Holofernes,* and gimel in *David and Goliath.* They also think that *putti* in *Zachariah* and in *Cumaean Sibyl* are flipping the bird, or giving the fig (2008, p. 136, 175).

MICHELANGELO SELF-PORTRAITS

Artists were not allowed to "sign" their work in the Vatican. As an alternative, Michelangelo included his self-portraits. Here are three examples:

The first is in *The Last Judgment* where Michelangelo painted himself in the dangling skin.

The second is in the Sistine Ceiling where Michelangelo portrayed his head in profile. It is carried on a tray in the *Judith and Holofernes* spandrel above the entrance wall (Vecchi, 1992, p. 36). (Is someone sticking out a tongue to the left of Judith as the sleeping warrior?)

The third is in the Sistine Ceiling in the *Azor-Sadach* lunette where Michelangelo is peeking over his shoulder (Vecchi, 1992).

Abrahams (Part 3, p. 2) finds a Michelangelo self-portrait in the detail of Phidias in Michelangelo's *Battle of the Lapiths and Centaurs* that he says is Michelangelo's earliest extant sculpture. Abrahams (Part 3) found another Michelangelo self-portrait peeking in the inner corner of the "eye" with the pillar in what I call the grand face. Abrahams interprets the grand face as "Michelangelo's face . . . [with] . . . Dante's profile placed within."

Michelangelo also painted himself wearing the Pope's hat in the impish reclining figure over the *Moses* sculpture (Blech and Doliner, p. 279).

Wallace (2010, p. 263) writes that Michelangelo portrayed himself as "Nicodemus" in the *Florentine Pietà*. Professor DeLuca (as told in Sunday Times by Richard Owen in Rome, July 2, 2009) thought that the fresco *The Crucifixion of St. Peter* that is in the Pauline Chapel has a Michelangelo self-portrait. He's the figure on horseback wearing a blue turban. But Wallace (2007) identifies the figure in the lower right wearing the gold robe as a Michelangelo self-portrait.

This section is only the tip of the iceberg, as Michelangelo seems to have left his self-portrait everywhere but I think not naked.

The only sculpture signed by Michelangelo was the Rome *Pietà*.

LEONARDO DA VINCI

Because Leonardo da Vinci may have painted Mary Magdalene in *The Last Supper* (Brown, 2003), and because he may have hidden some images (himself, monkey head) in the *Mona Lisa*, it seems worth examining his interaction with Michelangelo.

Capra (2007) points out that Michelangelo and Raphael were younger rivals, that they were contemporaries, and that da Vinci had battles with Michelangelo. White (2000) says Michelangelo had "edgy religiosity" and that Michelangelo

was the "reviled" enemy of Leonardo. Indeed they were both commissioned to do a battle painting (I thought Leonardo's sketch was superior) that remained unfinished. Leonardo was apparently jealous of the "lavish commissions" bestowed on Michelangelo and said that the Chapel paintings were "inappropriate Herculean figures" and that he had shown "no interest in science." The antagonism was supposed to have begun in 1504 when Leonardo and a committee chose to place the *David* inside the Loggia dei Lanzi instead of outside the Signoria.

Da Vinci did dissections. His sketches show a lot more animals than those of Michelangelo: lambs, bears, dogs, cats, and horses.

IS MARY MAGDALENE A CENTRAL FIGURE IN *THE LAST JUDGMENT*?

The woman who is sheltered and defended by the male figure in *The Last Judgment* is clearly pregnant. She is dressed in the same red top, blue skirt, as the *Doni Tondo*.

In the *Doni Tondo* the man behind the woman with brown hair, who does not appear to be pregnant, is balding with gray hair, mustache, and beard. She has a closed book between her knees. This painting is interpreted by Wallace (1998) as Joseph and the Madonna with the child Jesus.

A pregnant woman is also shown pointing to her belly in the severy above the *Roboam-Abia* lunette (Vecchi, p. 216).

In *The Last Judgment*, Mary's hair is mostly covered with white cloth, but what hair shows is a reddish color. The man protecting her is clean-shaven, he has his hair, and is presumably Jesus. The woman, however, if she is his mother is not shown as old. One could wonder if she is meant to be Mary Magdalene with child. The wildest notion I had about the blue blob is that it represents the fetal membranes and the amniotic fluid within, however, Mary's legs show clearly through the transparency. Her fingers are a "vee" shape that was made so much of as a symbol of the chalice by Dan Brown (2003).

In the *Florentine Pietà*, the most finished female figure is supposed to be *Mary Magdalene*. So I looked at her and at the woman beside Jesus in *The Last Judgment* and they are not dissimilar. I also looked at the carved Magdalene wondering if she looks pregnant from any angle.

MICHELANGELO'S SENSE OF HUMOR

If you have any doubts that Michelangelo painted with his funny bone, just look at God's backside in *the Creation of the Sun and Moon*. Now if I

had been painting that bit of fresco, I would have laughed so hard at my own witty cleverness I would have fallen off the scaffolding.

Consider also his impish self-portrayal of a man wearing the pope's hat in the *Tomb of Julius II*. Look at his painting of his critic wearing donkey ears and in a snake's coils in *The Last Judgment*.

Wallace (2010) writes about the lighter side of Michelangelo ("Jesting with Sebastian and Company," p. 172). He also gave his staff nicknames. Some of the names were things—Stick, Basket, the Little Liar, Dolt, Oddball, Fats, Thorny, Knobby, Lefty, Stumpy, and Gloomy. There were also Anti-Christ, Nero, Priest, Godfather, Turk, Rector, and Friar. Many of the nicknames were animals—Little Mouse, Fly, Chicken, Goose, Horse, She-cat, Porcupine, and Woodpecker. Could he not remember their actual names?

Still, Michelangelo gets labeled "terribilità." I can't say there's much sign of humor in his poems or letters.

Would Michelangelo paint and sculpt double and triple meanings with his tongue in his cheek? Absolutely.

SEA CHANGE

Ashford (2006) has suggested that Meshberger (1990) started a revolution about how the work of Renaissance artists might be viewed.

The Renaissance began with Dante in 14th century Florence and continued to the 17th century. Humanism was born. Artists strove to portray the human form. Scientific method, experiments, and evidence came into use.

Dissection revealed the human interior and suggested the manner of function. Da Vinci, Botticelli, Michelangelo, Donatello, Raphael, David, and Titian were the artists of the Renaissance and the human figure was a subject. The human figure is Michelangelo's primary subject. He would be familiar with gross human anatomy from his dissections.

What themes might he have in the chapel? Michelangelo was all about humans—created in the image of their creator. What could be more fitting? There's the historical narrative with the Biblical creation, the pagan prehistory, and the Jewish origins. Anatomy of man, inside and outside could be another great theme. The Devil is reduced to a herd of ram skulls. God and Jesus are the winners here.

As to whether I am "seeing things" that aren't there, I think that if I can see the anatomical images, a brilliant artist like Michelangelo saw and painted them.

SUMMARY

Anatomy or image proposed in the art of Michelangelo	Described by, in chronological order
Michelangelo's skin is self portrait	1929 self-portrait referred to in Wallace
Dante profile in *The Last Judgment*	1951, 1954 Gonzalez 2005 reviewed in Abrahams
Brain in *Creation of Adam*	**1990 Meshberger**
Pineal in *Creation of Adam*	**1995 Binkley**
Face composition of *The Last Judgment* delineated by blue negative space	**1997 Binkley** 2005 Abrahams
Michelangelo's skin is drip of nasal mucous in *The Last Judgment*, Heart in *Pietà*	**1997 Binkley**
Horns blown in "mouth" of *The Last Judgment* face	1951, 1954 Gonzalez 1997 Binkley
Backside in *Creation of Sun and Moon and Plants*	**1998 Wallace** 2008 Blech and Doliner
Kidney in *Separation of Water from Land*	**2000 Eknoyan**
Goiter in *Separation of Light from Darkness*	**2003 Bondeson and Bondeson**
Evolution of brains in ceiling	**2006 Ashford**
Brain coronal sections in *Last Judgment*, Raphael and David, *Temptation of Christ*	**2006 Ashford** 2007 Paluzzi et al.
Cloak is lung in *Creation of Eve* a list of the thirty some anatomies they identified in the ceiling is below	**2007 Barreto and de Olivieri**
Manhood pillar in eye of *The Last Judgment*, caruncles in corners of eyes	**2008 Blech and Doliner**
The Last Judgment shape is Moses' tablets	2008 Blech and Doliner
Figures posed in shapes of Hebrew Letters	2008 Blech and Doliner
Brainstem in *Separation of Light from Darkness*	**2010 Suk and Tamargo**

Heart in *Delphic Sibyl*	**2010 in this book**
Gall bladder in the *Cumaean Sibyl;* Barreto and de Olivieri think the green bag represents the heart	**2010 in this book**
Ovary, uterus, vagina in *The Fall of Man*	**2010 in this book**
Tongue *in Judith and Holofernes* Intestines in *The Sacrifice of Noah* and the bronze nudes	**2010 in this book**
Teeth, the "dancing figures" that are white in the columns across from the *ignudi*	**2010 in this book**
Female parts, possibly in *Moses*	**2010 In this book**
Male parts, St. Peter's	**2010 In this book**
Pope's hat is Sistine Ceiling over grand face in *Last Judgment*	2010 In this book
Mary is pregnant, possibly Magdalene in *Last Judgment*	2010 In this book
Blue skirt is "tear" falling from "eye "of "face," rocks in "nose" are dried nasal mucus; and there's a skeleton in *The Last Judgment*.	**2010 In this book**

When Gilson Barreto sent me *A Arte Secreta de Michelangelo* in Portuguese (2004), my husband Dr. Tatem (retired radiologist) and I went through the images, compared them to Vesalius' and to Morris' *Human Anatomy*, and translated Portuguese phrases using the web. The books index lists over 90 anatomies identified in Michelangelo's art. Here I have listed groups that appear together on a page of the book.

Aortic arch and cervical region in *The Fall of Man*, p. 20, 89
Hyoid bone in *The Separation of Light and Darkness*, p. 77
Brain viewed from below, Hypophysis in *The Creation of the Sun and Moon*, p. 79
Kidney in *Separation of Land and Water*, p. 82
Contour of kidney in *ignudi*, p. 82
Lung and bronchial tree in *The Creation of Eve*, p. 87
Tendons of the hand in *The Sacrifice of Noah*, p. 92
Bronchial tree in *The Deluge*, p. 95

Hemithorax and sectioned ribs in *The Drunkeness of Noah*, p. 97

Drapery compared, Pieta and *Drunkeness of Noah*, p. 97, 190

Muscles of the eye in ribbons around medallions, p. 99

Retina in medallion, p. 99

Vertebra in *Judith and Holofernes*, p. 105

Temporal muscle and zygomatic arch in broom of *David and Goliath*, p. 109

Testicles, epididymus, vasa, and duct in a snake in *The Brazen Serpent*, p. 111

Inguinal region vessels and nerves in *The Punishment of Haman*, p. 113

Eardrum and hammer bone in drapery of *Jeremiah*, p. 119

Cerebellum, pons, and medulla oblongata in drapery of the *Persian Sibyl*, p. 123

Distal forearm bones in drapery of *Ezekial*, p. 125

Epiglottis, vocal cords, trachea, and larynx *in Erithraean* Sibyl, p. 128

Zygomatic arch, mastoid process, facial nerve, temporal arch in *Joel*, p. 133

Spinal column in *Zechariah*, p. 137

Ethmoid bone in *Delphic Sibyl*, p. 139

Elbow joint bones in *Isaiah*, p. 141

Heart in *Cumaean Sibyl*, p. 143

Patella and Tibia in *Daniel*, p. 147

Ball and socket shoulder joint in *Libyan Sibyl*, p. 149

Penis cross section in fish of *Jonah*, p.153

Scapula in *Salman, Boaz, and Obed*, p. 157

Cochlea in *Rehoboam*, p. 158

Adrenal in *Uzziah*, p. 160

Double spinus process cervical vertebra in *Josiah*, p. 164

Medial cranial fossa in *Hezekiah*, p. 167

Scapula and humerus in *Asa*, p. 169

Mandible (jaw) in *Jesse*, p. 171

Chest wall, heart, and diaphragm in skirt of *Pietà*, p. 189 (different from Binkley above)

Shoulder and arm parts in knee and leg and arm of *Moses*, p. 206

ANNOTATED BIBLIOGRAPHY

You'll need a sherpa to help you carry some of these heavy but beautiful tomes. I have used **bold** to indicate authors that proposed anatomical interpretations of Michelangelo's work.

Abrahams, Simon, *Michelangelo's Art Through Michelangelo's Eyes, Parts One, Two, and Three*, 2005 (online at *www.artscholar.org*). The first article discusses and illustrates the profile of Dante suggested by Joaquin Diaz Gonzalez in 1951, 1954. The third article discusses the grand face that is the same that I wrote about in 1997.

Abrahams, Simon, *The Last Judgment: Michelangelo's Self-Portrait in the Torso of St. Peter*, 2007 (online), this article shows the image of Michelangelo peeking around St. Peter's leg.

Ashford, J. Wesson, The Brain, 2006 ; *www.medafile.com/MichelA.html*. Ashford has matched Michelangelo anatomical representations of brains in the ceiling to brains of dogfish, frog, cat, baboon, and human.

Ashford, J. Wesson, The Michelangelo Code, 2006, 8 pages, illustrations. *http://www.medafile.com/MiaCoda-JWA-06827.doc*. Ashford compares a brain section to the central ellipse of *The Last Judgment*.; he has matched a brain coronal section to the ellipse (my "nose" area) of *The Last Judgment*.

Barnes, Bernadine, *Michelangelo's Last Judgment: The Renaissance Response*, The California Studies in the History of Art, The Discovery Series 5, 1998, 160 pages (illustrations). This book has a collection of various artists' last judgment paintings, an analysis of the nudity with improper poses, a

discussion of Michelangelo's critics, and an analysis of the Dante influence in *The Last Judgment.*

Barolsky, Paul, *Michelangelo's Nose: a Myth and its Maker,* Pennsylvantia State University Press, Univerisity Park, Pa, 1990, 169 pages. He writes: "I sing of Michelangelo's nose, like his very body, was not in fact of colossal scale, but, like the rest of him, it took on truly gigantic proportions in its significance."

Barreto, Gilson, and **de Oliveira**, Marcelo G. *A Arte Secreta De Michelangelo,* in Portuguese, ARX publishers, 2004, 229 pages. There are numerous interviews and articles on the web showing bits from this book. The beautifully illustrated book is out of print but should soon be republished in English.

Beck, James (1930-2007), *Michelangelo: A Lesson in Anatomy,* Phaidon Press Ltd., London, 1975, and Viking Press and MacMillan, 73 pages. This is a black and white "coffee table" book that is for artists and art students about the human body. It has mostly closeups of sculpture and some drawings. It has a nice discussion of the colossus. (I found this book in the Pitkin County Library in Aspen)

Binkley, Sue, *Endocrinology,* Harper Collins, 1995, p. xiii. I wrote about Meshberger's article and pointed out that the pineal gland would be in the position of Eve's knee in the *Creation of Adam.*

Binkley, Sue, Fingertips, *Coyote Bark,* 1997. The pizza parlor was in New Hope PA; Michael added a brain after I showed him Meshberger's paper.

Binkley, Sue, *Biological Clocks: Your Owner's Manual,* Harwood Academic Publishers, 1997, p. 121. Here I describe how the composition of *The Last Judgment* is a giant face. I point out the trumpeters in the mouth region.

Blech, Benjamin, and Roy **Doliner**, *The Sistine Secrets: Michelangelo's Forbidden Messages in the Heart of the Vatican,* Harper Collins 2008, 320 pages. The main theme of this convincing book is that many of the "secrets" are of Old Testament and Jewish origin. There are even interpretations of the arrangement of some human figures in the shapes of Hebrew Letters. There's a description of what it is like to visit the Sistine Chapel today,

p. 129. On p. 36 they point out that Leonardo "signed" his name to the *Madonna of the Rocks* (1483) by using finger spelling for the letters LDV.

Bondeson L. and **Bondeson A.G**. Michelangelo's divine goiter. *J. R. Soc. Med.* 96 (12), 2003, pp. 609-611.

Brown, Dan, *The Da Vinci Code*, New York, Doubleday, 2003, 605 pages.

Bruschini, Enrico, *In the Foosteps of Popes*, 2001, 260 pages, a charming tour guide to the Vatican.

Bruschini, Enrico, *Masterpieces of the Vatican*, 2004, 160 pages, gorgeous illustrations. Has my favorite portrait of Michelangelo on p. 75 by Raphael.

Capra, Fritjof, *The Science of Leonardo*, Doubleday, 2007, pp. 19,24,29,100,120.

Connor, James A., *The Last Judgment: Michelangelo and the Death of the Renaissance*, Palgrave Macmillan, 2009, 256 pages. This book is available on the Internet.

Copplestone, Trewin, *Michelangelo*, Grange Books, Kent, 1998, 76 pages. This lovely book has color illustrations of Michelangelo's sculpture, paintings, and sketches. Page 48 has a nice wide-angle view of the Sistine Chapel showing *The Last Judgment* and the ceiling. It appears to be a night view as there is no light from the windows. A large reproduction of *The Fall of Man* is on p. 70-71. Note the cut off tree.

Coughlin, R., *The World of Michelangelo* 1475-1564, *Time Life Books* 1975, 202 pages. Coughlin p. 74 shows the best image of the *Pietà* that I have seen and writes that Michelangelo was "pursuing what he called the heart's image." This book, p. 104, shows the Greek statue *LaocoÖn* that is supposed to have influenced Michelangelo with its "writhing emotional expressive figures."

Eknoyan, G. Michelangelo: art, anatomy, and the kidney. *Kidney Int.* 57 (3), 1190-1201, 2000. The bisected kidney image is found in Michelangelo's *Separation of Land and Water* in the Sistine ceiling. There's an interesting discussion of Michelangelo's kidney stones. There is also a nice discussion of dissections at the time Michelangelo was involved in them. I was able to get this article online.

Goldscheider, Ludwig (1896-1973), *Michelangelo: Paintings, Sculptures, Architecture*, Phaidon Publishers Incl, Greenwich, CT, 1963, 263 pages. There are some color plates pasted in. This was before the restoration and the images are dingy by comparison. Plate 145 has the best picture of *Moses'* head. Twelve lunettes are shown Plates 112-123. Michaelangelo's curious signature on the *Pietà* is shown on p. 10. This book has the best picture of *Moses*—his face and his hands.

Gonzalez, Joaquin Diaz, 1951, 1954. *Quello che ho visto nel Giudizio Universale di Michelangelo (Rome).* Supposedly there was a pamphlet and several books. I have not seen them. They are referred to and discussed by Abramson in his Part One.

Hartt, Frederick (1919-1991), *Michelangelo*, Harry N. Abrams Inc., New York, 1984. This "coffee table" book has color illustrations mostly of the work in the Sistine Chapel. My copy notes it is a concise edition of Hartt's book published in 1964.

King, Ross, *The Pope's Ceiling*, Walker and Company, New York, 2003, 233 pages, illustrations. The book nicely describes the history of the Sistine Chapel and the process of fresco painting and how the work was paid. He also discusses the dissections on p. 156 and Michelangelo's sexuality on p. 196-197. There is a small section of color plates that includes three works by Raphael and Giuliano's portrait of Michelangelo.

Kugler, Franz, Charles Locke Eastlake, and Elizabeth Rigby Eastlake, *Handbook of Painting. The Italian Schools. Volume 1*, 1920. Republished 2010, Nabu Press, 392 pages. The part about the Sibyls is online, oldandsold. com, Michelangelo's Paintings in the Sistine Chapel.

Marian, Valerio, *Michelangelo the Painter*, Harry N. Abrams, Inc., Publishers, New York, 1964, 147 pages of prose and 80 some plates, the pages aren't

numbered. You'll need a dolly to carry this largest book in the Bibliography. This book has views of the medallions in the Sistine Ceiling.

Meshberger, Frank Lynn, An Interpretation of Michelangelo's *Creation of Adam* Based on Neuroanatomy, *Journal of the American Medical Association*, volume 64, October 10, 1990, pp. 1837-1841 and cover. Inspired by the article, I used the image of *Creation of Adam* on the cover of my *Endocrinology* book. The article has color illustrations.

Nickerson, Angela K. *A Journey into Michelangelo's Rome*, Roaring Forties Press, 2008, 163 pages. The book is portable, less than 8x8 inches. There is an exceptionally clear diagram of the Sistine Chapel on p. 68, and a clear diagram of the progression of designs of St. Peter's on p. 125. The book is a "tour."

Nims, John Frederick (translator, 1913-1999) *The Complete Poems of Michelangelo*, The University of Chicago Press, Chicago and London, 1998, 185 pages (I found this in the Pitkin County Library in Aspen). There are 302 poems in the book.

Palmer, Jessica. "God is more than a Flying Brain" 2008, and "Not again with the sekrit Renaissance brain anatomy" 2010, http://scienceblogs.com/bioephemera. The 2008 blog shows Paluzzi's finding of Gerard David's *Transfiguration of Christ* and mentions a brain image in Raphael's *Transfiguration of Jesus*.

Paluzzi, Allessandro; **Belli**, Antonio; **Bain**, Peter; and **Viva**, Laura, Brain 'imaging' in the Renaissance, *J.R.Soc.Med*, 100 (12), 2007, 540-543. I only had access to the abstract for this article.

Ramsden, E.H., *The Letters of Michelangelo*, Translated from the original Tuscan, Edited and Annotated, in Two Volumes, Stanford University Press, California, 1963. A quarter of the first volume is preface and introductory material.

Ruiz, Cristina, The New Da Vince Code: Secrets of the Sistine Chapel, *The Sunday Times*, timesonline.co.uk, June 15, 2008, 5 pages. I have so far been unable to locate Ms. Ruiz.

Salcman, Michael. *The Creation of Adam* by Michelangelo Buonarroti (1475-1564) *Neurosurgery* 59 (6): N11-2, December 2006. Dr. Salcman is a neurological surgeon and poet (*The Clock Made of Confetti*). About Michelangelo he wrote a poem, Ambiguity (in press, 2011, Notre Dame Review), "It may be true that God's draperies in The Creation of Adam resemble the inner aspect of the brain's hemisphere . . . I'm not too sure."

Saunders, J.B. de C. M. and Charles D. O'Malley, *Vesalius: The Illustrations from his Works*, The World Publishing Company, Cleveland and New York, 1950, 250 pages.

Stone, Irving, *The Agony and the Ecstasy*, Doubleday and Company, Inc., 1961, 664 pages. The book is a historical fiction of the life of Michelangelo. There's a bibliography and a Glossary of Italian words. There's a list of present locations of Michelangelo's works and those that have been lost. I watched the movie of *The Agony and the Ecstasy* (1965) while writing this. The movie looked splendid on my flat screen played as a DVD on my Blue Ray. It begins with a historical view of the sculptures. The fictional part is the making of the Sistine Ceiling. There are luscious colors and wonderful views. The DVD even has an intermission and that seemed very quaint.

Stone, Irving (1903-1989), and Jean, I. *Michelangelo, Sculptor*, Signet, New American Library, Doubleday, 1962, 243 pages. The book is mostly translated letters of Michelangelo. There is a black and white section of photographs of Michelangelo's work and an Index of people's names that have something to with Michelangelo. The copy I borrowed from inter library loan was marked "Property of the Army" and came from Fort Carson. The title is because the letters were signed "Your Michelangelo, Sculptor in Rome." The letters were written 1496-1563.

Suk, I., Tamargo, RJ, Concealed neuroantomy in Michelangelo's *Separation of Light from Darkness* in the Sistine Chapel. *Neurosurgery* 2010, 66 (5), 851-860, 2010. The article shows the brainstem that can be seen in a figure. The article has lovely colored illustrations and apparently even the cover. It was available to me from Neurosurgery online and Tamargo sent a reprint.

Vecchi, Pierluigi de, *The Sistine Chapel, A Glorious Restoration*, Harry N Abrams, Inc., Publishers, 1992, 271 pages, essays from "Michelangelo:

The Sistine Chapel," held at the Vatican, 1990. The book has diagrams of some of the *giornata*, p. 56. This book could use a list of illustrations with their pages. Shows a Michelangelo self-portrait in the front pages. P. 241 shows the additions and patches made in the restoration.

Wallace, William E., *The Complete Sculpture, Painting, Architecture*, Hugh Lauter Levin Associates, Inc., 1998, 267 pages. Has a useful Chronology p. 8-9. This is a large "coffee table" book. Some of the paintings are printed on tissue thin paper interleaved with heavier paper. The preface has a nice description of Wallace's visit to the quarry. Wallace is an art historian at Washington University in St. Louis.

Wallace, William E., *The Genius of Michelangelo*, The Great Courses, The Teaching Company, 2007. There are three boxes containing two DVDs each with 36 lectures. Wallace is the Michelangelo of lecturing. They are fascinating, original and perceptive, and didn't put me to sleep. We are fortunate that he made these recordings of his lectures. The art looks fantastic on the TV screen, better than in the books, luminous.

Wallace, William E., *Michelangelo: The Artist, the Man, and His Times*, Cambridge University Press, 2010, 401 pages. This is a prose biography with a small section of color pictures of Michelangelo's art. William Wallace is the living authority on Michelangelo. He's an art historian at Washington University in St. Louis. His lectures are available on DVD. This book has multiple wonderful indices: cast of characters, a list of the Popes of Michelangelo's life, works about Michelangelo, persons, and subjects. It is about Michelangelo the aristocrat. As the cover book summary says, "The belief in his patrician status fueled his lifelong ambition to improve his family's financial situation and to raise the social standing of artists."

Walsh, Meg Nottingham, "Out of the Darkness: Michelangelo's *Last Judgment*," *National Georgraphic* May 1994, pp. 103-123. This article has lovely pictures of Michelangelo's art.

White, Michael, *Leonardo, The First Scientist*, Little, Brown, & Co., 2000; pp. 5,68,84,228-230,232,248,324,334,338.

FINGERTIPS
Sue Tatem
1997

Keep in touch
Said Michelangelo

In the beginning he painted
A creator in the image of man's brain
On the Pope's Rio Grande ceiling
Shrouding it in a red meningeal cloak.
He curled an Eve
Behind the white haired man
And crooked her knee
On the pine cone pineal soul
And he well hung the pituitary
A dark foot below it
And he called it
The Creation of Adam

Keep in touch
Said Michelangelo

In the days that followed
He puzzled in the middle of the chapel
In the center of its whitebone skull
The pineal gland painter
Stood in the center of the mind
And he looked with his own eyes
And he saw vaulting arching eyebrows,
And he looked out his
Orbital window sockets
And he saw men,
Just as they are,
Naked.

So he laughed
And painted a pumpkin face
Eyes, nose, mouth

In blue lapis lazuli
And filled them with bare people.
He hung his own skin
A nose drip of snot
And painted noisy bugles at the lips
Of the naked men he saw
Through his chapel teeth
And he called it
The Last Judgment

Keep in touch
Said Michelangelo

And he threw his paintbrush
Into the air, high, end over end
It tumbled boneship
Across five hundred years
Of black space.
The paintbrush fell
Into the hand of Michael
Sculptor and artist
Where he stood painting
from a plastic tray
palette on a café table
wearing a red tee shirt
and white shorts
and thick strap sandals.
A bare light bulb lit Michael
And the tattoo circling his arm that was
Recreating the images of Michelangelo
On the walls of a pizza parlor
Gotcha!

Keep in touch
Said Michelangelo

I am.

BODY PARTS

After writing most of this book, I realized that most of the body parts are represented in the Sistine Chapel. Here is a list of parts Michelangelo might have dissected and seen and where they occur in the Chapel. I consulted Vesalius (Saunders, 1950) figuring that Michelangelo might have had access to similar gross anatomy information.

Body part, gross anatomy	Location in Sistine Chapel
Face (eyes, nose, mucus, tear, mouth, saliva, eyebrows)	*The Last Judgment*
Ears	Donkey ears on Minos
Hair or hat	*The Last Judgment*
Skull	Ram's skulls
Neck	*The Last Judgment*
Thyroid	?
Torso, arms, legs, muscles	Most figures
Behind	*Creation of Sun, Moon, and Plants*
Fingers and toes	Ceiling, ignudi
Genitals, external male	*The Last Judgment*
Internal male organs, testes	*The Brazen Serpent*
Brain, pituitary, pineal	*Creation of Adam*
Brain stem, spinal cord	*Separation of Light and Darkness*
Tongue	*Judith and Holofernes*
Teeth	Dancing pairs

Intestines	Bronze nudes and *The Sacrifice of Noah*
Gall bladder	*Cumaean Sibyl*
Pancreas	?
Liver	?
Stomach	?
Spleen	?
Female internal reproductive	*Fall of Man*
Female external reproductive	?
Kidney	*Separation of Land and Water*
Bladder	?
Adrenals	*Uzziah*
Lungs	*Creation of Eve*
Trachea, bronchi	Ceiling cut tree trunks
Heart	*Delphic Sybil*
Skin	On the figures and Michelangelo's flayed skin in *The Last Judgment*
Skeleton, shoulder joint	*The Last Judgment*, Libyan Sibyl

Cover, *The Last Judgment* as painted with acrylic by the author. Back cover, Author's self portrait watercolor with bandana and scallions

Imagine standing with me in the otherwise empty Sistine Chapel. I have a laser pointer and I can show you all the anatomies in this book. There are beautiful color versions that are easily accessed online. The figures attached here, black and white by necessity, are only meant to show you where to look.

1. "I painted the Sistine Chapel" BEFORE it was prepared for painting the ceiling and *The Last Judgment*. Notice the way the windows and structures above them look like eyes, eyelids, and eyebrows. The dots are in the "eyes." The scalloped ceiling even looks like a comb or jester's hat.

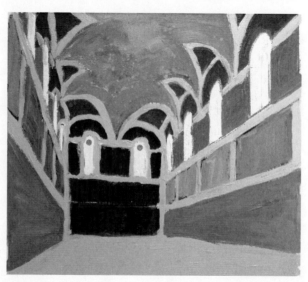

2. The white sketched lines show the location of the grand face in *The Last Judgment*. The higher dot on the nose is the location of the blue blob (Mary's skirt) that may be a tear. The lower dot indicates the location of the drop of nasal mucus that is Michelangelo's skin. The mouth region has figures blowing horns.

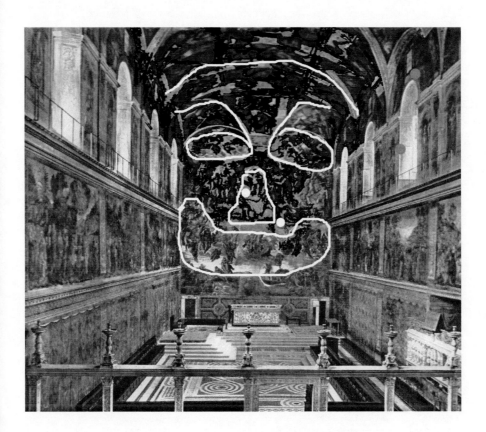

3. Detail of the *Creation of Adam*. The figures of God and the
 surrounding small figures are the "brain" located by Meshberger.
 I have circled Eve's knee (pineal gland) and the arrow points to
 the pituitary gland. Meshberger (1990) describes flesh-colored
 and pink brain parts that are represented: sulcus cinguli, articular
 process, inferior surface of the pons, spinal cord, pituitary stalk and
 gland, optic nerve, transected optic chiasm, optic tract and writes
 "this image has the shape of a brain." The outer red cloak is the
 meninges. A green shred of cloth is the vertebral artery.

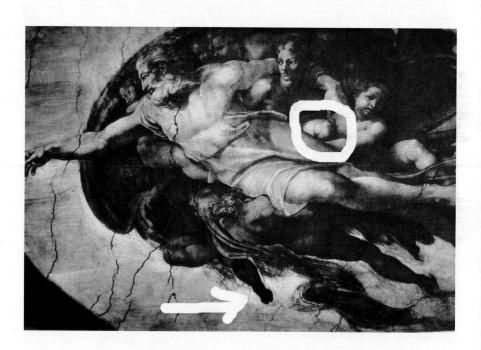

4. The *Pietà*. I have drawn a white line around the area of Mary's skirt
 that may be the ventricle (dissected interior) of what Michelangelo
 described as the "heart's image." Beside this I have put a simplified
 heart that I painted. There is one dot in the ventricle, two dots in
 an auricle, and three dots in the great vessels.

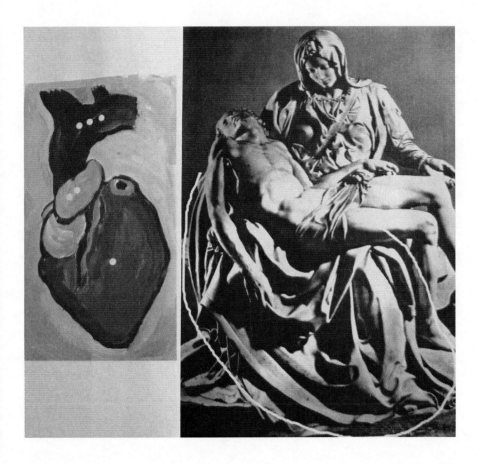

5. *The Fall of Man* may be the internal female reproductive anatomy. The fig tree trunk is the "vagina," the white dot is in the "uterus," the extended arms and branch represent the fallopian tubes ending in the leafy "fimbria" (two white dots) and an "ovary" (circled). Barreto and de Olivieri (2004) noticed that the small broken tree behind Eve is the aortic arch.

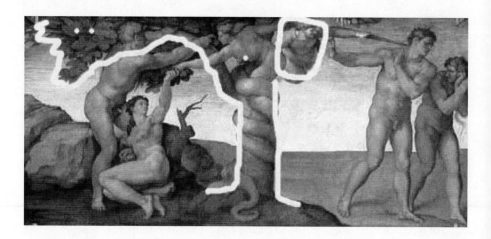

6. Detail from the *Creation of the Sun and Moon* showing the backside of God. The black dot is in the area of the buttocks. This image is interpreted as the frog brain by Ashford (2006) and as the brain viewed from the underneath by Barreto and de Oliviera (2004).

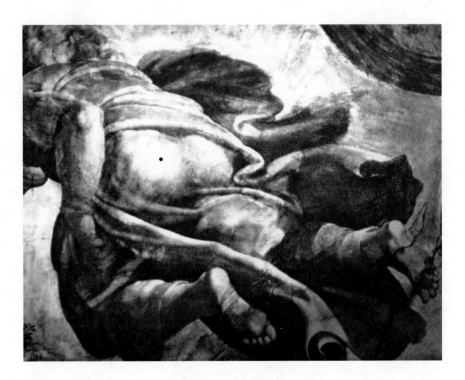

7. The "red robe" structures in the ceiling are marked from top to bottom: ovary in *The Fall of Man*, lung in *The Creation of Eve*, brain in *The Creation of Adam*, kidney in *Gathering of the Waters*, derriere and liver in *Creations of Sun, Moon, and Plants*, brainstem and spinal cord in *Separation of Light and Darkness*, and eye in *Jonah*.

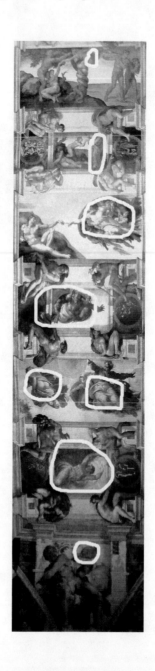

8. Detail from *The Last Judgment*. This is the "eye" of the grand face showing the leaning column. The white sketched line indicates the column and associated figures that form the "male organ" with the "scrotum" at lower right.

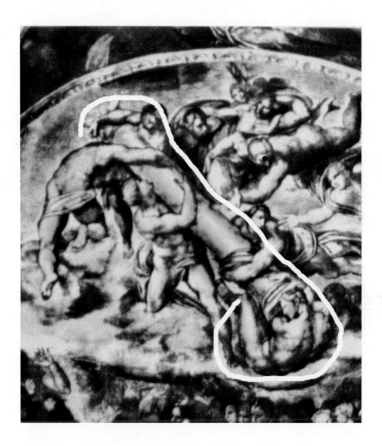

9. St. Peter's Basilica from the air.

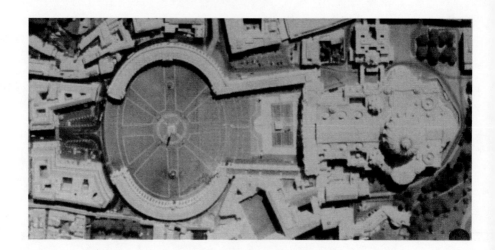

10. Another view of the Sistine Chapel, with white sketched lines to show a possible papal hat. Zechariah would be at the peak of the hat. The hat echoes the hat in the coat of arms. Michelangelo's self-portrait wearing the hat is in the reclining figure of the Julius tomb.

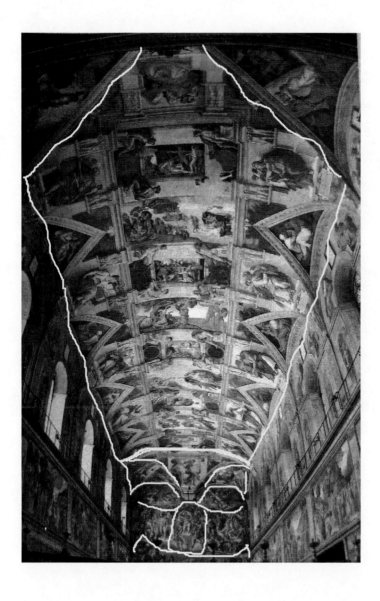

11. The green bag of the *Cumaean Sibyl* marked by the white dot. I am suggesting it is the "gall bladder." In the upper corners are two examples of the teeth, dancing pairs, marked by black dots. Barreto and de Oliviera (2004) proposed the green bag is the heart.

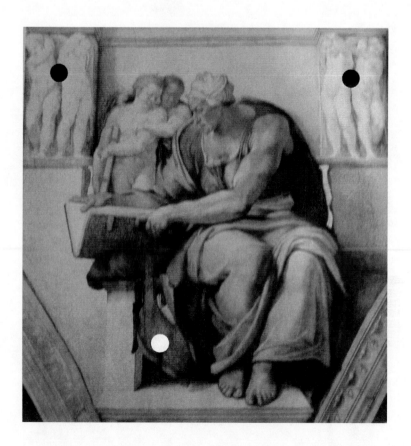

12. The tongue in *Judith and Holofernes* is marked with the white dot. Also shown in this detail is the tray bearing the head. The hand appears to be the biting head of a snake. The head above the arm may be in the position of the uvula. That is supposed to be a Michelangelo self-portrait in profile. I can suggest a sequence from this starting with Judith serving the head, to this tongue, through the intestines (bronze nudes, double wedges) past the dancing pairs teeth and the Cumaean gall bladder, to be excreted in *The Brazen Serpent*. On the other side the sequence starts with the beheading of Goliath that is swept into the intestines (bronze nudes) past the constricting snake sphincters of *The Brazen Serpent*. In short, a digestive tract sequence can be traced.

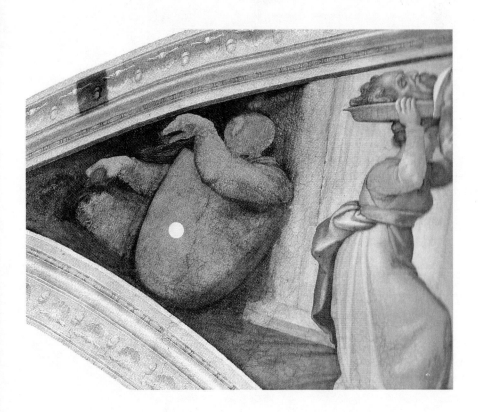

13. Moses is the guilty statue with horns. Notice the hand in his lap and the way he is pulling his overly long beard to the side revealing a dark cavity. Moses sits between Rachel and Leah who may represent some trick here. But Moses also had two wives, a Kushite he married in Egypt and Zipporah, his cousin bride. Zipporah is supposed to have circumcised their son or maybe even Moses himself, so that might explain what he is protecting with his left hand.

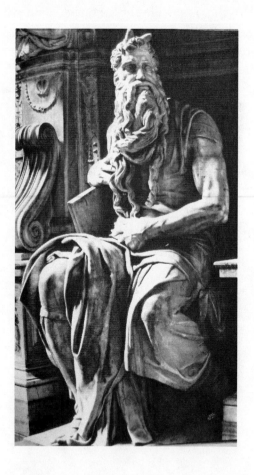

12. The tongue in *Judith and Holofernes* is marked with the white dot. Also shown in this detail is the tray bearing the head. The hand appears to be the biting head of a snake. The head above the arm may be in the position of the uvula. That is supposed to be a Michelangelo self-portrait in profile. I can suggest a sequence from this starting with Judith serving the head, to this tongue, through the intestines (bronze nudes, double wedges) past the dancing pairs teeth and the Cumaean gall bladder, to be excreted in *The Brazen Serpent*. On the other side the sequence starts with the beheading of Goliath that is swept into the intestines (bronze nudes) past the constricting snake sphincters of *The Brazen Serpent*. In short, a digestive tract sequence can be traced.

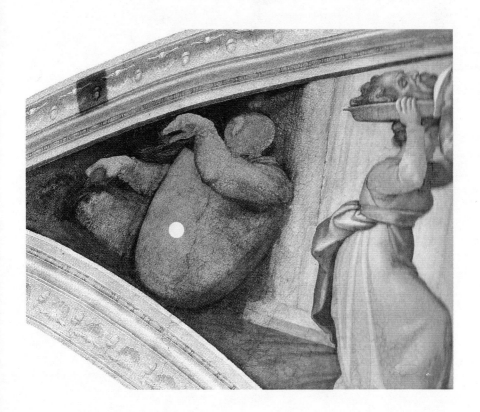

13. Moses is the guilty statue with horns. Notice the hand in his lap and the way he is pulling his overly long beard to the side revealing a dark cavity. Moses sits between Rachel and Leah who may represent some trick here. But Moses also had two wives, a Kushite he married in Egypt and Zipporah, his cousin bride. Zipporah is supposed to have circumcised their son or maybe even Moses himself, so that might explain what he is protecting with his left hand.

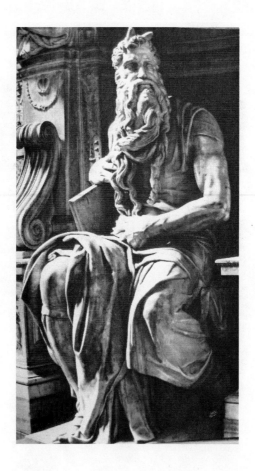

14. The dots on the diagram show where some of anatomy has been located on the Sistine Ceiling in this book: *Jonah* (eye), *Creation of Adam* (brain), *Creation of Sun and Moon* (backside), *Separation of Land and water* (kidney), *Separation of Light and Darkness* (brain stem), *Creation of Eve* (lung), *Fall of Man* (ovaries, uterus, Fallopian tubes, vagina), *Delphic Sibyl* (heart), *Cumaean Sibyl* (gall bladder), *Libyan Sibyl* (shoulder joint), *Judith and Holofernes* (tongue, white dot), double wedges (intestines), double wedges (small dots) and dancing pairs (teeth). It includes some of the dots that would be needed to mark Barreto and de Oliveira's additional anatomies. The point here is that the ceiling is full of anatomies.

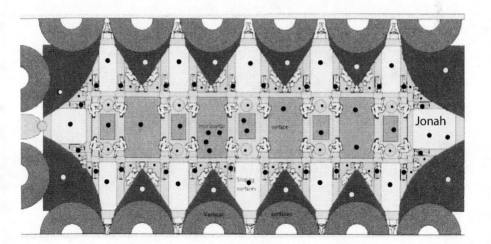

15. This is the impish figure carved by Michelangelo and placed above Moses in the Julius tomb. It is supposed to be a Michelangelo self-portrait and the naughty old boy is wearing the Pope's hat. This could be a way that Michelangelo referred to *The Last Judgment* grand face composition with the pope's hat.

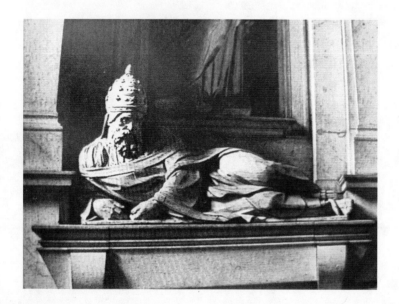

16. This detail of *The Last Judgment* shows the Jesus figure (one black dot by his hand with the Masonic sign) with Mary (two white dots) curled at his side. The "skin" of Michelangelo held by Bartholomew (Aretino) is in the lower right corner (3 white dots). At the bottom of the nose two rocks are in the position of dried nasal mucus.

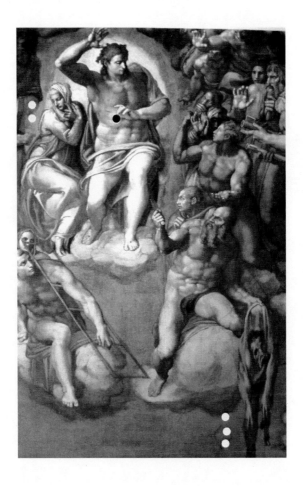

Edwards Brothers,Inc!
Thorofare, NJ 08086
07 December, 2010
BA2010341